Spill Ink On It
jennifer jazz

SPUYTEN DUYVIL
NEW YORK CITY

© 2020 jennifer jazz
ISBN 978-1-949966-72-5
Cover photo: Michael Belenky

Library of Congress Cataloging-in-Publication Data

Names: jazz, jennifer, author.
Title: Spill ink on it / jennifer jazz.
Description: New York City : Spuyten Duyvil, 2020. |
Identifiers: LCCN 2019045186 | ISBN 9781949966725 (paperback)
Subjects: LCSH: jazz, jennifer. | New York memoir--New York
 (State)--New York--Biography.
Classification: LCC ML420.J299 A3 2020 | DDC 781.64092 [B]--dc23
LC record available at https://lccn.loc.gov/2019045186

For Gorodish

AMBER

1

Teachers circling City Hall with union signs are the subject of newscasts at night while by day are the dreamy laugh tracks and car crashes of TV reruns. Boredom is a form of power that makes walls carousel when I lie on the floor after spinning. Aunt M's at work. Nanny hasn't retired yet, so Granny's who I find one afternoon when I reach the upper landing. She hands me a pen and begins using words no one else does that I don't respond in kind to since Albanian, Russian, Italian fit the "huddled masses yearning to breathe free" story—not her dialect that syncopates like marimba keys. It wouldn't be a stretch to say that some of my bloodline leads to Ghana. Granny's first cousin's name is Fante and it was an Antiguan custom during their generation to name children after the tribes in Africa they descended from. Legs bent. Face jagged. Hair forever scattered by trade winds. She's tiny compared to my grandmother, but her voice can ring with the fury of a griot. She's always had so much responsibility. Of course she flies off the handle easily, but there are few moments I feel as important as when I write letters for her to family back home and in England— especially when she takes the pen and signs "And so, I remain, Caroline Chapman," with such flourish in spite of how unsteady her hand is.

Granny's letter's on a night table for Aunt M. to mail later. I'm on my way to the vestibule to stare through the stained glass in our front door where green's a cheap thrill. Red a furnace. Blue a melancholy and amber the

undepletable half-life of minor memories when Granny calls out, so I climb the steps again, expecting her to offer me some of the imported candies she keeps in a lock box in a secret location, but am rewarded with a sugar cake I would have been ashamed to eat if I were outside that I enjoy without worrying someone's going to say, "What is that? Eww...." and am wiping flakes of ginger flavored coconut from my mouth with the napkin it was in when she grips the collar of her housecoat and gasps "Maju-de." But she's just sighting another *jumbie*. Aside from the cousins who stop by in outfits that would have only made sense during Queen Victoria's reign, ghosts are our only guests. She never begins at the beginning. Her visions come and go. Her brothers hope to find work on the canal being built in Panama and say goodbye. Then, she's begging God with all her might to please tell her whatever happened to them. A job contract she's been waiting for arrives from a family who needs a domestic. She waits at a dock under the trance of birds gliding, boards a steamship and arrives in Wales grateful not to have joined the loved ones who tumbled into the sea from capsized ships like scraps from a plate. There's little to no paying work in the post-plantation West Indies, so you find something across the Atlantic if you're lucky. Money is scarce. The man who seasons the stale piece of bread in his hand with the fumes of a pig roasting on a grill in the distance is one example of how hard daily life is, though sometimes I wonder if he was really someone she knew or a parable she'd been told about using your imagination to survive. Squeezing my wrist now with her hand mapped by a million lines, as if trying to embed

her voice into my flesh, she relives the day she was stung by a scorpion, something she's never brought up. She's under a tree, lightheaded. Sweat's blurring her vision when Majude, a deceased relative appears, telling her to crawl into the house and spill some ink from the well on the sting. The slick ebony liquid drip-painting her ankle soothing the pain and swelling as soon as Granny does what she says—but Granny's sagas always star women who advise each other on how to beat the odds. Women with more skin in the game than men.

"Uptown it's Alexander's," larger than life 3D letters against the Fordham Road skyline say. Alexander's being where Mommy and I and hundreds of other back-to-school shoppers in August vied for the best clothes stuffing the racks and piled in the bins. I had clung to a new lunchbox, marble notebooks and pencils as she tirelessly looked through as much as what was on sale as humanly possible, determined to turn me from a stick figure into someone real. She told me to stand straight. Held cardigans and wool skirts against me. But three weeks into the strike, I doubt I'll be needing any of the nice new things we bought that day. Then, suddenly I'm outside P.S. 73 for the first time since the end of second grade. Not many other kids are present. It's early.

"Albert Shanker is a pig without an ounce of respect for the families he's supposed to serve, but we don't need him and his flunky teachers. We can educate our kids ourselves," mommy says. A man dressed like a Hells Angel cutting the padlock from the gate. The corridors don't look familiar. "Michael row the boat ashore," some-

one's father sings as I'm for lack of a better description, "sleepy." A lady I recognize reads to us. The soup and sandwiches we eat in the cafeteria made from ingredients delivered after mommy called the mayor's office and threatened to incite an uprising like New York has never seen.

"I'm hoping they don't fall so far behind in their studies they have to repeat the grades they're in," someone says to someone else. But the people's takeover of my school ends as abruptly as it began, and soon I'm alone in the prism of the vestibule window again.

Girls with braids so tight their eyes are slashes dance between Double Dutch ropes. Jab step. Drop ice pop wrappers in front of what mommy calls "our property" and cleanse dirty candy by kissing it up to God. If only I could punch my way into my coat and dash outside as soon as they appear but am only allowed to after a tortuous grooming ritual.

"Sit 'dung! Hold still, nuh," Granny shrieks when I squirm as if it'll be my fault when I have plaits like a kid in a UNICEF commercial. The only thing worse is Nanny trying to trap my stubborn hair into a rubber band. Her smooth gray strands requiring nothing but a few strokes of the delicate antique brush on her vanity, she's the least qualified in our house for such a nowhere task.

"Stay where you can be seen," Granny repeats sounding so worried that I'm afraid that the girls watching me descend from our steps as if from a spacecraft are going to take it personally.

Whole streets south of ours have been burnt to rubble. There aren't enough fire engines to save all the buildings in the Bronx about to tumble to the ground next. Nobody ever says if the flames are lit by slumlords trying to collect insurance money or votive candles knocked over by careless tenants. But our house faces a quiet edge of Claremont Park and is removed from much of what's happening around it.

The strike rages on even when October begins. I read *The Last of the Mohicans, Ivanhoe*, Classics Illustrated comics. The book *Kidnapped* by Robert Louis Stevenson, which could be one of Granny's remembrances if the characters were West Indian and the narrative less linear. The Black Panther becoming a Marvel Comic character without a law being passed or a protest. Strange things transpire at times alright. But nothing fascinates me like Aunt M's room. There aren't braided tassels, vanity trays, porcelain ornaments or tapestries embroidered with flowers or geese in it. Her mirror's just a mirror. It doesn't have a gilded frame. Her clothes are smart. Made to measure. Her shoes so plain yet tasteful. In the photo of her on the wall that was taken at the March on Washington for Jobs and Freedom just as Dr. King was speaking, her face is bright with the force of his message. The trick is to remove one book at a time so I can put it back exactly where I found it and not get scolded later. But I can never help myself. Sitting on her bed, leaving creases in the earthy batik cover around it, I scatter paperbacks and hardcovers like mad. Too much reading will make you go blind, Nanny says, but *The Autobiography of Malcolm X, Before the Mayflower*, and

Down These Mean Streets, are giving my lonesome life power and personal meaning, which actually helps me to see better. Aunt M. is our family archivist. Leather bound photo albums that go as far back as the 1800's are stacked on top of her bookcase, the first bookcase I've ever seen outside a public library. I stand on a chair and take down one or two at a time. From the thick sepia card of my colonially costumed great-grandfather George in the wilds of rural St. John's to the Polaroid of my brother taking his first steps in wool knee pants, three quarter socks and a coat with a velvet lapel, we remain people of humble means more finely dressed than necessary. Almost every photo is marked with the date it was taken and the names of who's in it. Aunt M prints so precisely. The eldest of my grandmother's three daughters, she's always been essential to the upkeep of a home where everything has its place and chores are performed with a clockwork regularity. Dinner prepared each night at the same hour followed by mince pie or bread 'n butter pudding and tea. Dishes washed right away. Linen folded as it should be in a mothball sanitized closet. Soap resting a certain way in the dish. As academic minded as Aunt M is, she didn't go to college. Took a clerical job with the New York City Department of Labor right after high school in order to help Nanny pay the bills. She'll never marry and have kids or be able to assert her own needs into the scheme of things. In the summer she'll travel though, as hard as it is to believe that the free spirit gazing into the lens of a camera somewhere in London is the Cinderella who scours dishes alone at the sink after holiday meals.

"This is for Saint Vincent de Paul," Aunt M always reassures us as if a Franciscan monk were running out of patience waiting for our donations. A frankincense and burnt wax scent follows us along the Concourse after Sunday mass. We're a family stuck in the past. My grandfather's fault I believe because when he arrived at Ellis Island from a port in Liverpool, he was done sailing with the British Merchant Marines, but not with the heavy drinking men do out at sea so died at the tender age of 30 from whiskey made with wood alcohol, a concoction sold under the counter even after the repeal of Prohibition. My grandmother was pregnant with my mother as she sat in front of his coffin. Nanny, as we call her, couldn't raise three daughters by herself, so my great-grandmother, Granny, moved in, at which point the two of them created the greatest fortress ever built. It's obvious that Nanny was destined to be a young widow when I look at the wedding portrait in which she's levitating backwards in a fine flapper gown and veil while my grandfather's wheeling his top hat full steam ahead.

"Why didn't you marry someone else later, Nan?" I once asked.

"And let some man into my home I didn't know? I had girls," she replied with an indifference she only assumes when discussing men. On the occasions that she reminds my brother and first cousin not to be "shiftless" or "idle" she's only trying to save them from negative tendencies she feels are innate to their gender. Otherwise, she's the most emotionally aloof individual I'll ever meet and the close attention she pays to talcum powdering her face

or straight stitching new drapes at her Singer machine is absent. Honestly, I doubt that she would have gotten married if it hadn't been arranged. Tall and broad shouldered with neatly drawn features and a reputable surname, my grandfather, like Nanny, was an only child, so he too possessed the air of someone rare. Accustomed to the decorum of uniform and life among moneyless white men, he was a natural for the New York City police force, such gainful employment for a black immigrant that members of the Antiguan organization invested in the growth of their small Harlem community were sure he was a perfect match for the young mulatto product of a colonial finishing school that was my grandmother. My grandfather was not the slob that comes to mind when you think of a man who drinks himself to death, I mean. I'll believe that he died of pneumonia until I'm middle aged when Aunt M. will admit it was a lie Nanny and Granny created out of social necessity. No one will even ever mention where he's buried. But it's clear to me now that his having died so young as well as the circumstances of his death played a hand in the women he left behind deciding to just rely on each other and close ranks.

Nanny and Granny must have stood out when they arrived at Ellis Island together because Granny's removed from Africa by a generation or two but not by blood yet Nanny is the spitting image of her father, a Brit of German parentage named Harry Brand who Nanny exchanged letters with after first arriving in New York my mother once mentioned. But it's rude to bring up the blonde starry-eyed daguerreotype in one of our family

albums whose last name Nanny was born with. All you can do is assume that either he'd been a creep who had taken advantage of Granny or a bureaucrat exiled to the tropics who liked local women but wouldn't settle down with one.

2

It's 1968. Millions of Europeans have been welcomed into the U.S. But only a few thousand West Indians have been allowed to enter. Nanny and Granny had arrived before 1952 when the quota system simply identified them as British, but the distant cousins gathering in the upstairs living room on weekends lately are here courtesy of new immigration laws passed under the pressure of civil rights protests. Fante with her fantastic oblong head and eyes that look kohl painted but are just naturally that way, came to New York when she was younger so has the hang of it and is definitely one of us. Breaking the ice with the rest of my newly arrived relatives though—that's mission impossible. I mean they just gape without saying a word if I try to strike up a conversation.

"Children should be seen and not heard," Nanny says. That's why I startle them maybe, though winning the approval of distant cousins who wear white shoes and clothes in autumn is just going to keep me from being one of the cool kids, so I really shouldn't care. Kenneth dangling the snapper Granny prepares him by the tail, devouring it almost whole, firing bones from his mouth onto his plate before applying napkin to lips, should patent his technique for eating fish. New cousins around my age have just come from London. I had thought they'd dress like Lulu from the film "To Sir with Love," but their ribbons and plaits are straight out of Doctor Seuss. Years later, during the most warmhearted conversation, they'll tell me that Nanny had done so much to

help them begin their lives in the United States, but at this point, they're mechanical girls without a sense of humor who practice their math on sheets of blank paper Aunt M. gives us that my brother, sister and I prefer to draw on. What forms to file. Documents to fill out. Who can be sponsored to become a permanent resident and how long the process takes. What clothes and household utensils will be sent back home in barrels as soon as possible. Higher incomes and education will differentiate West Indians from other blacks supposedly. But such flashy data won't describe my family of mostly women with a history of being exploited who are more driven to become autonomous of the powerful than a desire to become one of them. My newly arrived relatives are interested in owning property, their own small businesses, and would deadpan you if you brought up playing the lottery or any sort of gambling being that they're cautious with money to a degree Americans would find miserly. Even my mother, a major risk taker, will prefer to keep creatively hidden stashes of cash around the house than hand it over to a bank.

"If wishes were horses, beggars would ride," Nan says under her breath when she hears someone showboating. Granny and other women from 'home' had a financial circle in their early Harlem days, to which each one contributed. Once a month, one getting the whole pool of money that she could spend on something she couldn't afford otherwise. Managing fine among themselves without fees, penalties and other financial trickery. Nanny's a member in good standing of the International Ladies' Garment Workers Union. The seamstresses she

toils beside five days a week are mainly from socialist countries so expect ample benefits that reps demand in their behalf. Nanny, who turns Himalayan mounds of fabric into pricey gentlemen's attire, will soon collect a decent monthly pension, health insurance and other quality of life necessities. Aunt M's job with the state has also given her a stability women who namedrop are brainwashed into thinking they don't need. If there were a labor party on the ballot in America, I have no doubt my father, Nanny, Granny and Aunt M. would get their votes. Mommy's first job was executive assistant to Mme. Fernande Garvin, the Vice President of the Wines of Bordeaux and Alsace, on the other hand. But my mother's high-ticket tastes will rarely be sustainable without our blue-collar family member's good credit and savings.

Camille's gold tooth that glows when she smiles. Charles in his cuffed trousers and double-breasted jackets with his shiny Chairman Mao forehead and sun baked complexion, never raising his voice above a murmur—they're my godparents from St. Croix. And what's not to like about being the honorary daughter of a couple who never had their own? His palm on her knee. Her fingers settling between his as easy as windblown leaves as they sit on the sofa beside me. It's strange not being called "fickle," or "contrary." Just having my arm steadied when cutting my first communion cake. I'm at a point when I feel hopelessly different than everyone else and so isolated, but my life will never be more perfect than it is now I'll realize when it's too late to appreciate it.

The strike rages on. "Ladies don't whistle." Nanny says. Warning that I'll go blind if I read too much. When I sit with my chin in my palm, "twiddle your thumbs," she recommends. Her voice is part Popeye, part pirate's parrot. She can be playful. But Granny considers the simplest remarks I make rude and as soon as that *fungee* stick's in her fist, I dash back downstairs.

"Oh, please," mommy sings with a slyness as if she couldn't give a damn when the Board of Ed strike has finally ended. Like the bogeymen attacking Toyland at the end of *March of the Wooden Soldiers* and the balm of Thanksgiving turkey condiments through the house is all we need. Streets without crossing guards. Kids without homework. A smart family watching the world fall apart becomes self-reliant. Our new olive green Chevy Nova's basically a lockbox on wheels. Cars parked on our block tend to be American classics with scratched side panels, rusted wings and fur dice cubes dangling from their rear-view mirrors, but ours is more of a giant Faberge egg.

Mommy works the gas and brakes like an inventor testing a flying machine once she has her license and I realize she's carrying out a plan to gradually transcend things she finds troubling—isn't the hot head that she seems. For someone who dresses with as much verve as she does, you'd think she'd like all the attention she gets. but she doesn't. Ransacking a drawer of antique soup ladles and cold meat forks in search of a sharp enough knife to chase a convertible full of guys with Elvis side-

burns who followed her back to the house once. Being the daughter of a highly talented tailor, my mother was destined to be clothes-centric but to the men who cat-call her, she's more than a trendsetter. She's second to none. Mommy's style and electricity are better suited for show business than family life though, even if she calls anyone famous she's met "a phony." She could've been introduced to Sean Connery one night at an upscale club but preferred to keep her distance, she told me. Bela-fonte came on to her but she wasn't interested, she said. The famous designer, Oleg Cassini handed her his num-ber between floors in an Upper East Side elevator after asking if she'd model for him, but she discarded it. It's taboo to bring up that my father is her second husband or that her first was an amateur boxer named Rafael Pi-neda who mamboed her off the dance floor of The Chee-tah and down the aisle. It's a total no-no to mention that my brother was Rafael Pineda Jr. until my father entered the picture, adopted him and changed his name.

Mommy marching back and forth to Afro-Cuban mu-sic with a broomstick for a partner swinging her head from side to side, disavowing all haters and singing in broken Spanish. That's one of my first memories. Nei-ther Granny nor Nanny wore slacks or danced, so mom-my does both with a vengeance. The name Hazel being an ovation to the color of her eyes, it's no wonder she's a narcissist—though a strange kind who will empty her pocket for anyone with a sad enough story.

Daddy's name is Jonathan. Mommy calls him JD though. His mother died when he was young, after which he and his two brothers were raised by his father

who I might have met once before he died. All my parents have in common is that Daddy was brought up in a house of men and mommy in a house of women so they both missed the presence of someone of the opposite gender so much that neither will ever live up to each other's neurotic expectations. Mommy's cloisonné tea cups. The whisper of daddy's high hat and brushes. Eyes narrowed, finessing his tie in the mirror with Miles whistling like a tea kettle in the distance. He met my mother during a time when the first true language of the urban landscape burst from Freddies' Fatman, The 845 Club, unnamed basements and bars around Boston Road. Daddy found mentors. Acquired precision in the local drum and bugle corp. Figured out the nuts and bolts of improvise at bebop jam sessions where if you were patient, you got to play. Touring with a band managed by a fella named Mo Gayle who booked gigs for them around Ontario. You performed six nights a week. Got one night to rest. Thelonious Monk lived on Lymon Place. Daddy and a friend of his getting a cryptic sort of enlightenment when they'd stop by his crib. Uncle Skeeter once claiming Monk's cat knew how to use the toilet. Uncle Skeeter being Skeeter Best, a guitarist who gave Kenny Burrell lessons, recorded with Sonny Stitt, Ray Charles, Milt Jackson etcetera. I call all my father's friends "uncle." Uncle Tina is tenor sax player Tina Brooks who's played with Jackie McLean, Freddie Hubbard, Lionel Hampton and others. *True Blue*, one of Uncle Tina's albums released on the Blue Note label, has a track on it titled "Miss Hazel," an ode to my mother that sounds like it could be the theme score to a popular TV show.

Uncle Beener is Oliver Beener, a trumpeter that played with Hank Crawford and Ray Charles. Some compare him to Miles. He's the subject of the title of the photo *Oliver Beener and Group* taken in 1960 by Roy DeCarava, just months before or after I was born. My father is the stylish drummer in the foreground in silhouette with his shoulders angled. I have no idea where daddy acquired such good taste, having grown up without a woman in the house, though Nanny may play a role in how well his suits are tailored. I'm watching the Beatles on Ed Sullivan in the apartment we rented before we became homeowners when my father pauses beside me, with his mouth curved in disdain at Ringo and makes fun of the way he holds his sticks. But these are the last days that Daddy will shuffle out to our car tugging drums, hardware and pedals with a Pall Mall wagging between his lips in spite of my always wishing that his band the Jazz Messiahs had stayed together.

Mommy clashes with Daddy over many things, one of them his unwillingness to defend her to the extent her first husband, who once right-crossed a guy who had gotten out of line with her at a party, did. Their cries rise from silence like sniper fire. It can be bone chilling. I have no idea sometimes what sets them off, though one constant point of conflict is the kitchen. The sight of her tilting a bottle of red into a pan of chicken cacciatore instead of the food he ate at home as a kid, his cue to have dinner elsewhere.

She finds peace in driving. I go wherever she goes. Sometimes this works out but sometimes she's just running from things that upset her, I'm her passenger and where we'll end up next, I don't know. I prefer the strength in numbers of trains and buses, but sitting beside her in our car is less isolating than usual one day as she races along the Henry Hudson Parkway like we're in a speedboat on the river next to us. A motorcade without beginning or end is dragging south into Manhattan. Gusts of wind with big soulful pauses carrying us north instead. It's January. I still haven't returned to school but have created my own curriculum. I jot down things I think are illuminating but don't make sense when I look at them again or bake apples in a Suzy Homemaker I doubted I'd ever touch after removing the Christmas wrapping paper it came in.

"We're still in the Bronx you know," mommy says smiling at me like I'm younger than she is for a change and not her equal when we coast off the highway and enter an area of gingerbread sort of houses hidden in evergreens. The further we drive, the less sun there is and the wider tree branches extend. Vines attacking the windshield on a dirt road she fights with the wheel to navigate. It's my first time in the discretely well-to-do area in the hills above Van Cortlandt Park. Riverdale Country. Fieldston. Horace Mann. Some of New York's most rigorous private schools are on estates like the one we begin to cross once we're out of the car. Hoffman being the one of choice for hippy parents. Mommy wouldn't know a joint from a stick of patchouli incense, but her disdain for so-called authority figures might make this work.

Gone is the prison yard at P.S. 73 where boys lobbed dodge balls that would sting my legs and arms. Gone are the rumors that the Savage Skulls will jump you at 3:00 if they so much as find the colors red, white and blue on the label in the collar of your shirt. Hoffmann's laidback. Students live in public housing, scenic homes along the Hudson and everything in between. We're a diverse bunch who eat lunch in a small unfussy kitchen together. I call my teachers by their first names. Mommy still gathers my hair into a chiffon bow, but I put on a pair of John Lennon sunglasses and a Nehru jacket that I pin a Peter Max button to when she's done. Classes are held in creaky rooms where beds and lamp tables would fit better than desks. Motown's too cheerful. I play Abbey Road backwards over and over to try and find out if Paul is dead. Anne, a thunderously quiet woman, is our principal. Her husband Malcolm was once a lawyer for the Department of Justice. Like many of my classmates, they're Jews. Aunt M has walked picket lines outside businesses that don't hire blacks with the Jewish couple sitting beside her in a photo taken at a banquet for members of the local chapter of the Congress on Racial Equality. Kosher bakeries, delis with Hebrew lettered signs and synagogues, they've been part of my life for as far back as I remember. The antagonism between the largely Jewish Board of Ed and families of color that the teacher's strike agitated has no place here luckily.

No more standing on my toes to look out the window in the vestibule wishing I could play with kids I don't have anything in common with. Our parents pick us up, dropping us off at restaurants, movie theaters, a bowl-

ing alley. Once in a Volkswagen van with a peace sticker on the bumper: What should we call our band? Our band needs a name, everyone's shouting even though none of us know how to play instruments. I write a song on a guitar lying around the house that only has three strings. The lyrics a warning that human beings are poisoning themselves, polluting the planet. I make a tape of myself singing it. I want to be part of a revolution, transform things. I don't trust kids who just do their homework and try to make good grades who I can tell are already all out for themselves and totally down with the system. My mother will say that I have a "mean streak" once and I'll wish so hard that there were a certain number of Hail Marys and Our Fathers I could repeat to reverse it. It's hard to like myself. I don't know what I'd do if I didn't have my buddy Chance—an only child who lives in a chain of recently constructed resort white buildings near our school. Standing on his terrace, the sky's always radiant and the trees sway come what may. He listens with interest when I speak and is my first real friend. If someone were to ask me to describe him, I probably really couldn't because I'm someone who will ball money into their pocket without counting it, though I have observed that he's taller than I am, is blonde and also slouches. His life looks perfect. He has so much privacy and space to be himself in without worrying about offending brothers and sisters with different temperaments and tastes. I get lost in the view outside his living room where he bashes the cymbals on his drum set as hard as he wants, neither a neighbor or parent ever appearing to complain about the noise.

He has his own key that he uses to let himself in after school. We eat lasagne his mom leaves for him in the frig and listen to albums that are everywhere. Jethro Tull. Ten Years After. Country Joe and the Fish. Steppenwolf. Creedence Clearwater Revival. Circus Magazines. He's obsessed with rock and it's contagious. There's this door in the basement of his high rise that leads to a rec room where we find tables set for a bar mitzvah one Saturday. Lifting the cellophane wrapping from a plate of cookies and eating some, we're convinced that we're invisible to everyone but each other so can get away with anything. A Fillmore East ad in the shape of a theater marquee in the Village Voice is what leads us to be climbing out of our car to see Genya Ravan and Ten Wheel Drive well past the time normal kids our age would be out alone. Mommy's instant rapport with the man behind the box office window who simply nods and waves us in having something to do with them both hating Nixon. Guitar, wine, reefer, sweat. Everyone's taller. Other than that, I can't see them. Red, white and blue psychedelic lights wilding. The zeitgeist of kids tossing flowers at cops in riot gear or Angela in black leather with a raised fist. The bands on stage so tiny compared to the waves of us throbbing and hungry for more than just watching and listening that the music raging only part fills in.

3

It's around this time that I lunge at a boy beating me at chess, clearing all the pieces from the board in one clean sweep because I'm not cut out for a game that idealizes feudalism, colonialism, elitism and segregation. Of course, he just called me a sore loser. But I don't like how you have to victimize someone else to win. I consider most games unnecessarily petty. Can't take them seriously and have the same heated opinions about grades. Even in the relaxed and personal setting of my new school, I'm still confined. What I like is sitting in the barn for my weekly pottery class with the privilege of just touching and enjoying the scent of clay, especially when it's raining. I know I'll never have to perform long division or recognize the symbols on the chart of elements. I'd rather spend my time doing things that interest me like playing with my Suzy Homemaker. How I can smell the heat as soon as it's plugged it in. Watch the rods glow. A tiny model of an actual oven, it actually has a real function and when I put an apple in it, it bakes, then I eat it. There's always the same outcome—unlike a chess match that's gone awry a few moves in that I have to endure no matter how pointless it is to keep playing. I also enjoy running my eyes around my head like a flashlight in the dark, not looking for anything in particular, for extended periods and just recollecting. I resent having to do homework, tending to forget I had any, not that Mommy notices. Daddy does double overtime at his job on the regular. The odd occasions that he's present, sitting by himself reeking of brandy and staring down adversaries only he can see.

Jonas is who I remember this dusk that the heavy harmonica theme to "Midnight Cowboy" is accompanying my brother and I home from the movie theater where we've just seen it. Jonas and I had walked from school together in first grade. He didn't speak English. We were the same size and the people we passed by were so much bigger that we'd wave goodbye again and again to each other with so much feeling when he'd reach his building. Ratso Rizzo, a rat in human form in a city so rife with romance that even being a scavenger was promising if you got the hang of it. If only his friendship with Joe Buck had lasted forever and he hadn't died on that bus at the end. I'm nine years old and the only thing I'm sure that's worth having in the future is a true friend so can't stop the tears running down my face.

"Don't expect me to plan out your whole life for you," mommy answers after I ask what she thinks I should be when I grow up. I get anxiety attacks about what I'm going to do when I'm not a kid anymore and need to control them better. Driving me to school, she's usually silent, keeping her eyes firmly fixed on something incredulous approaching from up ahead. Her life is hers and mine is mine a lot of the time, so I'm not sure if she's coming to see the Spring production of *The Mikado* in which I have a small part or just going to drop me off at school then pick me up when it's done, but she attends, even bringing Nanny and mingling a little afterwards. Once we're back home, I assume she's in bed recovering from the pressure of being in a group of parents, something she's never liked, so I struggle to carry my

bike down the steps in front of our house without asking if I can go outside in order to give her time to rest. My cousin is waiting for me at the bottom. Aunt D's inside for a short visit with Nanny and Granny. I want to joke around with him before they begin their trip back home a few stops away on the train. I do a quick scan for kids who occasionally appear along the high wall around the park across the street. Kids who jump down looking for easy targets to steal things from that their parents can't afford to buy them. What their point of origin is exactly isn't clear. I just know that the park can be a tense border between my life and theirs. My brother got his new Flexible Flyer sled taken away from him on a hill in there pretty much as soon as he'd gotten it for Christmas, but nobody's in sight when I check today. The whole block's empty. Any noise I hear is coming from far away, so I feel safe from the humiliation he had endured returning home without the present he had just gotten, the drama of mommy putting on her coat before demanding a description of the boys who took it that ensued. Swinging my leg over my bike, I use it as a chair, and since my cousin and I are confidantes sometimes, I begin to tell him how strange it was to have been on stage earlier. My cousin's the reincarnation of Nanny's forbidden to talk about white father, Harry. Harry's DNA having evidently swum against the tide of the gene pool, resulting in my cousin having been the rare black infant who looked like the Gerber baby. The picture of him in a classic christening suit in the picture in a fancy frame Nanny keeps on her vanity would look perfect on a jar of pureed apples or carrots. His hair has darkened over the years, but his

cheeks are still pretty rosy. His cute pug nose and eyes so sparkly and clear are somewhere in the lenses of his horn-rimmed glasses, but barely. My cousin the classic geek. He likes to play chess and read, even has a subscription to Famous Monsters magazine. Roughed up by other kids in the building where he lives and ridiculed at his neighborhood school to the point where he's already a loner. Conversations with him get bitter fairly quickly. Nine years old and already convinced that the world is effed up. I try to make him believe that we can do anything we want and nobody can stop us. Insisting the future is going to be better though just leads to us arguing. So, I'm avoiding that trap now by leaning my elbows against my handlebars and making the lady who had told me how beautifully I had spoken my lines during the performance today, sound like someone gullible who had pretty much fallen for a prank.

"She really thought you were good?" He asks grinning and shaking his head in disbelief when the little light seeping through the long branches obscuring the street is eclipsed by a shadow that happens to be mommy who looks pretty outraged because I'm outside without having asked first I figure, but then she spits the word "Bulldagger," at me in disgust with her eyes erupting from their sockets, and I realize that not wiping off my black pencil mustache when I had removed my costume had been a bad move. So much for having fun and showing off a bit for my cousin. I've never heard the word "bull" and "dagger" grafted together and imagine a creature as surreal as a centaur or a sphinx. Another girl had also played a male role. We had all dressed up to be some-

thing we weren't. A minute ago I was lighthearted and joking. Now I'm being bullied out of thinking that little girls should have mustaches when I know that already. I don't think little boys should have them either, but I'm just using my imagination, the right I thought I'd been given when she put me in a school where it's cool to do your own thing. I don't waste any time getting inside to wash my face, staying at the sink much longer than even necessary. I don't just try to remove my fake mustache. I'm so ashamed I try to wipe away my face away with it. When I finally get the nerve to look at my reflection in the mirror again, I'm younger and shirtless. Mommy's tugging me out of the living room where guests are having drinks.

"Always be fully dressed if there are men in the house," she says, measuring her words with more care than usual, but with her eyes blazing and as shocked as I am by what she's saying, I know she's trying to protect me. What's funny is that Nanny never swears, will say "H-E two sticks" to avoid using the word "hell" whereas my mother can make an adversary only using the obvious four-letter words sound amateur by comparison. I have no idea why she has such a foul mouth or short temper. But Nanny had to be the breadwinner almost as soon as she gave birth to her, so Granny ran the house and basically raised mommy by lambasting and striking her into complying with the same demands she has of us to act like kids did in the old days.

It's the window you left open Mommy accuses, blaming Aunt D for the high fever and malaise Granny suc-

cumbs to. Pointing her fingers at doctors who didn't work hard enough to keep Granny alive instead next. Tissues stained with mommy's mascara rising into a garden of dark carnations around her. Granny wasn't supposed to die even if she was born in 1885 and it's 1969, but either our car really does fly or mommy had plans for a post-Granny era that she kept to herself. Nanny and Aunt M are already in their own apartment further up the Concourse less than a year later just as we're finally done packing one radiant day soon after. Heading towards greener pastures (even if "white flight" is what they'll call the mass migration from the city to suburbia). Mommy racing north deep in introspection. Daddy following somewhere behind us in a truck with our dog, a cat we recently found and all our possessions while I already miss the days when I loved with my eyes and just smiled at things I liked.

GREEN

4

Homer Price has a pet skunk. Encyclopedia Brown solves mysteries. Henry Reed and Midge Glass have such groovy adventures I want to imitate them, so when a kid sets a snake in a Tupperware dish on his desk and asks if I want it, of course I say yes. Naming him Socrates because he's far from, because it's a cheeky kind of prank a storybook character would pull. I have reservations about touching him. Few members of the animal kingdom get such bad press. He doesn't have a burning longing to be hugged and stroked. He's no puppy. I develop an emotional attachment to him quickly, in spite of all this, understanding the only reason he spits his tongue at me is because he's so much smaller and basically scared. If only my father were able to see his vulnerability. But girls don't play with snakes. Girls feed dolls from toy bottles and style Barbie's hair, he thinks. Later, the snake as a phallic symbol thing will rain down on me like a ton of bricks. The unconscious ways my behavior was being processed. The snake could be poisonous, Daddy insists, but Socrates' not poisonous. I know because he sank his fangs into my hands once. Two stripes dripped from two parallel punctures. Bleeding should always be so polite. But a snake's not a house pet, Daddy argues. I lose and out Socrates goes. The very night I put his box on the patio it rains. Rainwater trickling into the holes punched in the lid, filling the container he's in and drowning him. I think a lot afterwards about what I could have done to save him, only random boys from around the corner, some of them who I've never

seen showing up at the front door because they've heard I can run fast and want to race me, freeing me of my misery. Even if I'm over a greasy sink of pots and pans, I dry my hands and follow them into the street. An older kid who runs on the track team at Salesian showing up after practice still in his shorts, Adidas and jersey. You'd think he would have left me in the dust, but it's almost a tie. I sort of crouch with one leg behind the other, tour into orbit and land on the finish line, unaware of my feet ever having touched the ground. Never trying to win— simply joining forces with whoever's beside me to topple the wind.

A camera's around my neck and I'm all souped up riding a careless bike made from the parts of other bikes. Easing up on the pedals. Gliding, dropping between trees with a plan to dip into the woods off a parkway that isn't exactly a wildlife sanctuary, but where I hope to get lucky and snap a picture of a unique bird or something. But I think I hear someone call me as I'm on the way and learn that if you jam a front brake when you don't have a back one when speeding down a hill you somersault through the air. Once I land on my head, the lesson ending. Such love and warmth the ground gives compared to mommy bullying me into opening my eyes, which is the last thing I remember when I wake up in either heaven or a hospital and spoon broth into my mouth that tastes of my own blood. Some woman in a gown the same as mine stepping out of the unknown holding a hand mirror she makes me look into that I already know before I do that nothing simple is happening.

Like mommy providing enough detail to anyone who asks where we live to make it clear our neighborhood's not the dismal Bronx border town they imagine when they hear "Mount Vernon." Nearly everybody does this. Distances themselves from their pasts. The newly arrived rarely making eye contact or waving, never mind revealing where they're from. The more people know about you, the more they have to hold over your head. "Don't tell them anything," mommy dictates. Giving me advice about "them" as in those who already live here who will soon run like hell to get away from us as we'll flee the coming wave of undesirables, but "As soon as you move into a neighborhood, you don't want to leave there anymore," I'll hear a crossing guard on line in front of us at Genovese's pharmacy explain.

"I wonder if they're related to Manny Shapiro," mommy quizzes herself as she's eyeing the guy in the house across the street because if he is, it means he's from our former stomping grounds slightly north of Yankee Stadium and she's closer to solving the mystery we're now in. It's simply the accent that proves they're slobs, she'll say. But names—names are our Achilles heels as names leave nothing to the imagination. Changing the spelling's one way to control being stereotyped, but you could only get away with it as long as you're among people who aren't shrewd enough to smell a rat. Better to change it all together than anglicize it in a city where so many of our grandparents arrived at the same sorry port at the Statue of Liberty, that "the immigrations inspector misspelled it" line comes off as total B.S.

One of the first times I'd been outside alone in my life without permission or Granny fretting close by. We had just moved in. I had no idea where I was going. It could've been daybreak but for it being afternoon. I mean the calm, the newness. In my mind, my arms were outstretched and I was soaring towards the sun when a car with a high-powered engine eased up beside me. There were two, maybe three of them inside, the one in the back with his elbow half out the window remarking, "Hey nigger," the same as you'd say "Hi" and that were my name. It would be the first but not last time some random antagonist would try to redeem a history where I'm down and they're standing. The problem is I'm not supposed to live on my own street. The playground next to Saint Ursula. Gramatan Avenue never quite feels right. I stay clear of the bocce ball court in Hartley Park. Blocks where American flags fly are off limits. I learn that the hard way. Aunt D. will ask my mother why on earth she chose to buy a house in the white section of a segregated town. My mother will never answer. She resents being questioned. Prefers to concentrate on the locations of whoever said what before she touches up her makeup in the rear-view mirror as if observing herself from millions of miles away. They're usually gone when we get there. But one night when my sister and I are carrying boxes of pizza back to her car, a teenage girl watching in frustration hocks spit on the ground and calls us "Niggers," before Mommy leaps out from behind the wheel, snatches her by her hair and uses it to sling her head against the glass of the restaurant we just left.

Blame it on the train tracks that slice Mount Vernon in half, one side for whites the other for blacks. You know the situation in a town's dire when the federal government is called in. A.B. Davis, the middle school in walking distance from us is under a court order to be integrated. It may look like a fort on a clifftop but it's a madhouse where kids from distant housing projects roll in on cheese buses and go berserk, or at least that's what I hear. All this talk supposedly only freaks out local white families, but black couples arriving on the northside don't want their children to go there either after finishing sixth grade. Parochial academies less costly and selective than elite private schools are common alternatives. A tight little building attached to a chapel that looks like a toy house you'd snap together is where I find myself. They must be missionaries picking up where their parents left off in the Andes and the Gambia, only with a plan to spread their goodness to the biblically needy black population of suburbia. Tornadoes carry whole houses 600 miles per hour through the sky where they come from I hear. They're American to an eerie extent. Fortunate is only disguised as a teacher. A woman in a bonnet and bouncing hoop skirt traipsing across the Western prairie is who she really is I think. The chalk she taps against the board with such force and speed always breaking as she rushes to impart mandatory skills to us within a specific time frame or else. We're a mix of grades and ages. They seat us in box formations. Malcolm X's youngest daughter's desk beside mine. Sometimes I forget he's her father and we pass notes back and forth with funny drawings or jokes on them, and sometimes

I can't ignore how much she resembles him. My mother, brother and Aunt M. are wearing black armbands again. Somebody's sobbing and I already know that the gun will be the only hero this country will ever have.

The kid who sits across from me is kind of a neat freak. Jeans creased. High tops laced just right, always clean. One part for notebooks. Another part for the shiny folder where he keeps his homework. His book bag is well arranged. I like when his markers cross the line where our desks meet and he doesn't mind if I use them. They're not the average back to school supplies. They look expensive. He swipes the paper with his fingers aimed. His tag is PEZ. Mine's "Hang Loose" because the title of a song by Mandrill was the best I could come up with. His letters belly laugh. It's just luck if I can do anything but scribble. Bombing notebook paper's how I survive boredom and assert my true urban identity. I walk. Other kids get out of cars that pull up in front of the chapel, but Pez lives in the South Bronx and reaches this street near the Fleetwood Metro North station by taking a series of buses. He's got to be the most extreme example of someone whose mother doesn't want him in the school in the neighborhood where he lives. The romantic identification you develop with things your parents lose sleep over. I've seen him padding down the hill at three o'clock with cans of paint in a separate compartment of the bag strapped to his shoulders. He's studious and looks it, which can be deceiving. If the cops ever catch him spraying his name on public property though. It'll be all he wrote, no pun.

You jump. Dip. Dribble. Rubber balls reverberate. Watch the clock until you're blue in the face but its hands don't rotate. Marvel's dead. Nobody ever read DC comics so not much to say about them. The latest issue of Right On! Magazine will do the rounds if we think the teacher's not paying attention. Page after page of the Sylvers and the Jackson Five's sunny smiles having the same effect on me as jelly beans and chocolate Easter bunnies.

5

Goldie on the front line of the black power revolution. Bullets shine. Fly. Sing. Searching the dark for a way out of the totaled car two cops have him cornered in. You can tell he's a martyr within the first five minutes. Staring between the bars of his cell, his sublime glow is all you notice then. He's a victim of the conniving black woman in bed watching as he stands naked in a loin cloth innocently observing himself in a mirror. He's no villain. After all, it's she, who as soon as he gets out of prison exclaims, "You look good to me!" with a predatory kind of glee. And it's she who comes up with the idea that he be her mack, which will justify her being the first "ho" in the stable he'll oversee with the cane he'll wave like a magic staff. It'll justify her being the blood diamond he'll trade to fund his coup against the man. "She's the woman who brought me into this world," he'll say about his mother after she's dead, since a woman's not capable of mattering otherwise in this movie in which the homage "In Memory of a Man" appears across the screen before it begins. Homoerotic yet not homosexual, Goldie purrs at you in every frame. Slim noticing Goldie's shirt's unbuttoned, teasing "You're showing some 'tiddy too, niggah," even puckering up and pretending to breastfeed from Goldie's chest. One of the two cops that constantly stalk him, pet and caress him in a softly lit alley, whispering in his ear.

"You were one of my best boys," the Blind Man reveals to Goldie. "I hated losing you," he laments. Pimps

in "The Mack" styling and preening themselves with a catty disdain for the women who work for them.

"I told her to give him a little taste" Pretty Tony recounts telling one of his hoes, "Cause he sure as shit wasn't getting none from me," he adds slyly playing hard to get. But it's when the lines blur between brother and bitch that The Mack's neon lit tour of the black male ego casts its sexiest spell. Goldie's brother Olinga, the messenger of a sixties social agenda that has lost steam, seems jaded by comparison in spite of his red, black and green skullcap and muscles. Goldie, in contrast, is a self-made entrepreneur emulated by street boys who plead to get behind the wheel of his Caddy. The only little black girl in this film is repeatedly squirted in the face by a water fountain she struggles to put her lips to, a phallic metaphor that's obscenely prophetic. It's not just the creamy "Brothers 'Gonna Work It Out," ballad that cascades over the differences between Goldie and his brother Olinga, the Mack's idealized view of brotherhood enables the two of them to syncretize into one. Even after Olinga realizes it's Goldie's fault that their mother's dead, the two joining forces against "whitey" instead. If Goldie is the most beloved black male character in the history of film—no other will influence fashion, music, language and sexual politics as much for decades to come—it's because he's Godzilla, the National Association of Colored People and Bert the Chimney Sweep all rolled into one.

Boys with windblown spores of hair who can't quite hit the high notes in "Side Show" by Blue Magic—but

almost can who strut by in coats with fake fur collars, flagging bell bottoms and platform heels—are the polar opposite of Daddy in his tarnished watch that makes it possible for him to clock double and triple overtime in his office in the tunnel where he dispatches trains. His co-workers limping back to their Cadillacs after cook-outs in our yard doing so with a weariness that flies in their trophy wive's faces during the last days when a man's supposed to do the heavy lifting and a woman just has to extend a neat martini when he walks in.

The Obsidian Blonde is only against discrimination in as much as it excludes him he said laughing, but I could tell he was serious, this one time we spoke on the phone. Not a thing more I can think of to say about him except that he *wonk wonk wonks* when he speaks which is totally unnatural for someone built so solid but is the typical ventriloquist dummy voice that black kids who go to white private schools assume.

Dirk and Timothy. Between the chapel and the building with the gargoyle above the door is where I usually see them. Dirk lumbers. Timothy diddy bops, trying to play it cool while still adhering to our fussy dress code. I'm just starting to develop, so only realize that I forgot to put on a bra when his eyes are tilted low and burning through my shirt. One particularly awkward moment, he, Ben and Karina, the daughter of a lawyer who represents famous athletes, and I are in a lounge of fine furnishings that call up the scene in the classic mummy movie where the scholar's deciphering the curse on a relic. Supposedly, we're having fun that only black kids can

have together—at the same time that the four of us have as little to do with each other as dolls do with the hands moving them. Timothy tugs me. I fall into his lap like a plaything he misplaced and has found again before I break free of his grabby fingers. Freaked out. Trying to catch my breath because a guy's never treated me so trivially before.

Female day students are being admitted for the first time since the year in the 1800's that New England Unitarians who played a role in creating Harvard decided there should be a prep school like it. Just a few of us girls between droves of Lord of the Flies boys who live in dorms beyond all the trees. In a smoky stairwell, upperclassmen with ties tossed over their shoulders and lacrosse rackets tilted against a wall, light cigarettes they're allowed to as long as they have permission letters from home. That's where I run into Karina on my way from a Latin class taught by a villainous old coot who humiliates me by asking me questions he knows I can't answer.

"You friggin failed," Katrina says laughing as an icy draft that's been making its way up my skirt reaches the nerve ends of my teeth, and I just stand there shivering, waiting for her to stop beating around the bush. I've gotten F's on all of my papers. I can never make sense of my daily schedule so am almost always late for classes, but realize she's talking about the midterm exam I nearly sobbed through. They post your grades in a hall where everyone can see. I expect to be caned across the knuckles next. Karina only makes A's so she considers

anything otherwise a rare form of entertainment. But I thank her before she walks off sneering, preferring to think she just did me a favor in some way that I'm too stupid to understand.

6

I get in the car twice a day with the sullen aspect of someone who has fallen into a hole in the ground too proud to call out for help. Mommy never notices how low my morale is or asks how I am either.

"I feed you. Put clothes on your back and a roof over your head. If that's not good enough, tough," is her mantra. They had described me as "disruptive" on a report card last year in sixth grade, my only prior having been that I was allergic to penicillen. My mother wasn't having it, had marched into the class to confront the teacher who had such negative opinions about me. Then, I ended up here because, "you're smart," mommy announced as if rehearsing for an argument about me with someone else.

Trying to start the Nova each morning once the temperature drops is like reviving a loved one whose heart has stopped, and anything I say once the engine is rumbling would be trivial by comparison. She gets flustered when I ask her for advice. Sometimes even pissed. She has a lot on her mind. I hate myself for needing more from her than she's able to give. I'm ashamed I'm so needy. I just want to talk really. You have to be sick or in danger. Need a real reason, but during Christmas break, I finally just say I'm not fit for a fancy private school.

"And what would you like to do now?" mommy sings in the tone of a waitress with other tables to get to.

Even a school circled by cop cars every day at 3pm has to be better than one with a headmaster for Christ's sake, I'd been telling myself as well as other stuff like, "Go for it. You've been an outcast almost everywhere you've gone so far. Davis Middle School can't be as bad as it sounds. What have you got to lose?"

Bite marks in my hand almost right away is how I'm rewarded for such wishful thinking. Showing up midway through the year dressed so politely. If I'd had any sense, I'd have kept my head down and at first I do, but a couple of months in I opt to play the dozens during an English class where no one ever pays attention, wanting to reverse the shame of everyone laughing at my prim and proper little clothes. I would have bought Cons and Pro-Keds in every color before showing up here if I'd had the guts to ask that we do back to school shopping all over again. So of course, the girl at a desk right next to mine goes in on what I'm wearing.

"Oh snap," someone says when, "Are you by any chance related to Ernie on Sesame Street?" I ask changing the subject because something has gotten into me. I'm feeling light-hearted. What an amateur I am, but they're in hysterics, are amused, which surprises me since what makes these kids tick is hard to guess. They're not an easy read.

"Let's see how funny you are when we're outside," the girl warns after the bell rings, not looking particularly angry. The only thing on my mind at dismissal time when I step out the main doors buttoning my coat, is heading to the candy store and filling my pockets with banana Now and Laters and these soft round caramels

with cream fillings that come in packs of six. But there she is, waiting and not by herself. A whole bunch of other kids close in on me. So now, I'm moving in the same direction they are. I don't have a choice. We move towards the park and basically, they're in charge of whatever happens next. Her heart isn't in it any more than mine is I observe. They're kids she rides the bus with every day, so she's under pressure to make a little violence at recess seem exhilarating. Taking off her earrings, bobbing with her fists balled and face pulled tight. I don't think she'll actually hit me. She gives me a shove. I fall, wishing someone would pass me something to wipe the cold slimy mud from my hands and help me back up as I sit there for a second trying to connect the dots between the silly comment about her I'd made hours ago and the bloodthirsty faces not letting me out of the ring they have me trapped in before I rise to my feet again. We grapple. I manage to put her in a headlock, something I've only done to boys when play fighting. I don't have a reason to hurt her and am thinking she realizes the same about me. She's some naive clumsy girl you'd see singing her heart out in the front row of a gospel choir, not someone to really fear I remind myself at the moment my thumb becomes a bloody dental impression of her teeth. You'd think, I'd have learned my lesson but I'll play the whole name calling game again in another class with a boy I actually have a crush on who will up and slap the shit out of me and leave a fingerprint of his hand on my face.

"Why don't you leave her alone?" I finally shout at Alfred after he makes yet another depraved remark to a

top-heavy girl that sits between us in a general science classroom because I'm tired of sharing his padded cell and have given up on the teacher who communicates in trombone noise from somewhere else like an adult in a Charlie Brown cartoon.

"Ooh, ooh. You 'gonna take that?" boys behind him instigate as Alfred just looks at me through his mystically pixelated eyeglasses half smiling. I can't wait to get outside later and escape the insane number of degenerates that grab girl's breasts and asses in the halls and stairwells or approach you like they're going to. They call you a "scab" if you're not what they consider pretty. You're a "tack head" or even worse if you don't have long enough hair. A whole vocabulary created to rate the extent to how worthless a young black woman is that leaves me speechless. But it's three o'clock now. I'm relieved that Hell has an exit and am following the high wall that barricades the school from Gramatan Avenue, when there's Alfred slightly up ahead, surrounded by a mob of kids who even before they close in from all sides, I'm sure have plans for me, so there's no point in running. The tide pulls me with it. Next, I'm on a corner on the other side of the street. More and more breathless kids arriving, elbowing their way in for a better view of violence they see all the time but never cease to consider showstopping. Someone shoves me into Alfred in order to get the action 'crackin. Alfred can see fine without his glasses I'm surprised to learn when he carefully removes them, then bats my head like it's a pinata he wants to split open before anyone else gets their try at it. Blows keep coming. I probably swing back at him, but in the clean cotton gray matter of my brain, I'm asleep.

A quarter of my face is purple. It hurts when I blink, but the swelling and bruises gradually go away. The blood staining the ball of my eye is gone within a few weeks. I'm a wild child my brother and sister probably think.

"You're a hippie, Jennifer," my grandmother chuckles under her breath.

My father has no words, just shaking his head before rushing back underground where the reckless get electrocuted at least.

"There's a way to do someone in with a tightly rolled newspaper. To hide a razor blade in your mouth," mommy says sounding just like Jimmy Cagney for a second before pausing to figure out how what she just said might actually work. But it's hard to take such extreme advice from someone who's constantly reminding me that walking barefoot on cold tiles is bad for "my female organs."

"If a boy fought a girl back when we were young, he was a friggin punk," she vents squeezing the living daylights out of the steering wheel, driving me to school the day afterwards. A tone's being set, she's insisted since Nixon became president. Something vicious below the surface clawing its way through she refuses to ignore or just shrug and make room for. Barging into the main office, demanding to see the principal, his secretary looks shocked that black kids beating other black kid's asses isn't always friendly fire while I keep telling myself that I'm not paying the price for having left a private school with a high-sounding name as much as having gone to one in the first place.

7

Mommy doesn't know how to make soul food. Worse yet, she refuses to learn. We eat potato salad in the yard in the summer, but she doesn't think it belongs on a holiday table. She's proud of how well she roasts a turkey, an arm of brisket, the artful sauces she makes with a dab of Bordeaux, burnt flour and pan drippings as well as her recipe for classic West Indian rice and kidney beans. A set of gold brushed china her father bought at a port somewhere in Europe is enshrined in a fine cabinet. She takes her time arranging weighty Wm Rogers and St. Edwards silver Nanny no longer uses, staging the meal in the way she remembers, except now on a smooth mahogany table with chairs resembling thrones at either end. The collectible chandelier suspended above it not décor or a source of light even as much as an effort to keep the home she grew up in alive. But daddy was born on the bandstand at the Blue Morocco, has never been at home in the era of her antiques. Goading her for not knowing how to cook collard greens or fry chicken his way of balancing the scale, though he's a fool to provoke her because there's no turning back once he does. "Get thee behind me Satan," I remember her reciting while tossing holy water on him from a font near the altar at our old church.

Our beige stucco English Tudor with brown trim boards and a slate tiled roof was designed for a vampire. Not a black family of five. We're supposed to have a mirrored bar and pool table in the basement, but our cellar's a dungeon. Unused rooms no one ever goes in that cast

shadows the size of islands. Secret steps created for servants that lead up from the kitchen and intersect with the first landing of the main staircase. Houses in this part of New York were built during the twenties by an affluent class escaping the crowds and polluted Manhattan air. Being some of the first blacks to arrive here, we're pioneers too, but for heaven's sake, there are only five of us and twelve rooms. We refer to some of the excess ones by their colors. The yellow room not just yellow because it's painted yellow, but because it gets more sun than the others. I'd describe the red room as magic realist. A reproduction of Picasso's Three Musicians over the sofa in there sets a strange mood. The Axis Bold as Love poster is a perfect fit for the planet discovered through a toy telescope that we call the "purple room." I'll read a Donald Goines novel I find on a dresser in there that makes me even more frustrated that I haven't met a pimp or a hoe yet in spite of the blacks next door he and Iceberg Slim make them out to be. The family room has casement windows that are easy to climb into during the rare moment when the front door's locked. Nobody goes in there, in spite of its soft and fuzzy name. It's a forgotten space where you'll find my father's lonesome drum kit and an out of tune piano. My brother's musician friends will rock out on their instruments and he'll belt out Hendrix cover songs with his 'fro wrapped in a sash borrowed from a living room curtain in there at one phase.

The decor here is a giant curtsy to the proprieties of my mother's upbringing. Yeah but also the digs of a woman who party hopped around Greenwich Village in

turtlenecks and pedal pushers with the actor who played Ben in "Night of the Living Dead." Enter our house and enter the mind of a wild child with a guilty conscience. That's what I mean. You could call it a spectrum, all these colors and design schemes that don't exactly blend. My sister's sunshine shrieking its brightness across my Berber blue refuge. My permanent moonlight boxing her pink walls and princess curtains in as sure as moss pries its way through fault lines in the patio tiles.

My cousin the neat freak living in a house where Christmas trees aren't dragged out until spring, raking his sandy colored hair with a metal pronged pick, perched on the side of my bed, shoe laces tied, shirt tucked into jeans firmly belted as if he wants to be ready in case his parents show up to get him. Both of us born just months apart, he's always been close by—but living here with us because Aunt D. and Uncle Alan have broken up isn't much of an alternative with my parents always acting like they're on the verge of doing the same thing. Tons of suspense. You never know when the end is coming. Only that it's near. Sometimes, he sleeps on the groovy shag carpet below my bed, and we talk all night in the dark. Him sounding like a kid no older than five or six even though he's a teenager.

"Does the devil choose certain people Jenny or is he random about who he possesses?" he asks hours after we've seen "The Exorcist" at a suburban multiplex with a screen the size of a windshield that was nowhere in the league of Loew's Paradise's in the Bronx with its lavish velvet curtains and opera house style balcony that

kids would toss down Milk Duds and Junior Mints from during matinees.

Aunt D, someone with a kindness that strikes me as a moral leaning and not just the customary singsong niceties of a relative, is now in some kind of mental hospital being treated for I don't know what. There's not much conversation about it. Life as my cousin knows it is gone, but I forget that he's hurting because of the way he does it. Reading "Soldier of Fortune" magazines and anything he can get his hands on that has swastikas on it.

"Learn how to dance. Get a girlfriend," is my advice to him during the soul searching conversations we have on our way home from the public library where we take cover from each other's clashing opinions behind separate piles of books. We fell apart as soon as Granny died, he says one day. It's hard for me to believe that someone so out of synch with the modern world was what held our family together, but things made sense when she was still with us, and now they don't, so maybe he's right.

8

Even on winter mornings when the oil burner's not working and under my blanket is the best place to be, I climb out of bed hooting like an owl and dance boot camp style into any pair of pants within reach, which ain't easy with three dogs running tight circles around me. The blade on the can opener so dull, it never cuts the way it's supposed to, but I manage to shake out the pink foie gras gloop with my fingers slashed by a million jagged Kennel Ration cans and clasp on their chains. They tug. I follow the pull. Pausing with patience whenever they squat or pee. All our dogs have rebirth narratives that rival the Messiah's, but Thunder's mommy's pride and joy.

She was in a salon the first time she saw him under the arm of a street hustler that strolled in. Had enough cash in her bag to buy him and still pay for a wash and set. This was back in our previous house from which he'd bolt out the front door at times, getting struck and dragged for a half a block by a blue Impala finally. Coming home from the animal hospital with a Frankenstein scar in his forehead. My father connecting the dots between that head injury and his violent temper. Mommy just insisting that Thunder's her protector. Whenever she's upset, he is. No denying it. He'll attack any man he perceives as her antagonist. Lunging for their arm. Fangs pronounced. That chainsaw growl rolling. Holidays tend to be the trigger for him to totally lose it because during holidays, my parents are in the house together for long stretches, which is tough for them to do

without clashing. Screaming matches sending Thunder's fangs into action as the fireplace dances and the nativity statues under our tree blink.

The Osmonds. The Partridges. Even the Bradys sing together. Then, there's us. Neighbors averting their eyes when I step outside our house as if to shield themselves from something fatal you can catch. Not once did my parents lose their tempers at Disney in Orlando last Spring. They made an agreement not to and kept it. Gliding around in a shiny rented car, with wind scattering my hair like birthday candle flames. I kind of miss it, especially when I walk in the house one afternoon and realize Thunder's not there. Mommy coming home and saying she's tired. As soon as I tell her he's missing, her springing back to life on a spiteful kind of adrenalin. The two of us have just begun to search for him when a knowing gathers in her face.

"What did you do with him? Where is he?" she interrogates my father once he finally appears. But he won't tell. Another confrontation to end all confrontations. Him caving in after a few days and admitting that he took him for a ride, letting him out somewhere in the South Bronx. She wants to know where precisely, but he's spoken as much as he's willing. So now I'm roaming a neighborhood that was once the primary destination of the wailing fire engines of my earliest memories. Riding shotgun. Scanning every inch of each block we ease our way through. In the photo of him on the xeroxes that we tape to lamp posts, Thunder coming across as an animal of unique importance. Our phone number, even the promise of a reward is on them. We're trying to find him

for real. Handing fliers to anyone Ma has the impression is sympathetic. She goes inside stores. I stay attentive and case the sidewalk when I'm waiting. Leaving some dingy bar where a man inside told her he's seen a shepherd sniffing around the garbage recently, she smiles to herself and plays the gas pedal with extra feeling when she's back behind the wheel.

She's just parked in front of our house, and I'm decidedly not expressing how incredible it is to be free of the car and be able to move my arms and legs again, when my father bursts by looking guilty about what he did with Thunder, just as it's clear to him that I have doubts about riding around with mommy trying to rescue an animal so vicious, but these are the roles we're stuck in.

I get distracted in the passenger seat, forget about searching for him at times and try to figure out things like how a TV with a smashed in screen and mangled baby stroller survived the flames or if they were later tossed into tall hills of ash we coast past. I imagine the lives of the kids who live on the devastated blocks we scrutinize and can't imagine that they're really expected to stand by their desks and pledge allegiance to the flag every morning at school. Mommy senses he's okay but says he won't have a chance once the cold and the snow kick in. For almost a month, we've been searching. A bold rain is attacking the windshield when I zoom in on a soggy mutt against a backdrop of singed brick and debris on a block we've crawled before. I call his name, not sure it's him and am overcome with emotion when Ma slams the brakes sobbing and in he dives all slimy and with such a stink.

Then, just like that, I'm not playing private eye in Hell. It's sunny and I'm in the Garden of Eden with Nanny. She's clutching a pair of cotton gloves with her wrist stashed at a certain angle. Toes pointed. Handbag like the Queen's in the crook of her arm. Gekkos nervously scooting back and forth across the walkway she takes. She's doesn't have to be an Episcopalian or a Catholic today, is an Anglican again on her way to a cathedral where she hasn't attended service since she was younger being that we're *Home*. The home that's not where we really live but that both nourishes as well as stifles our small family. Nan, my sister and I staying with Antonia in her house on Fort Road in St. John's where we sleep inside mosquito nets. It's a miracle that she and Nanny corresponded all these years. They were classmates at a private school for girls with European fathers. Antonia's was Portuguese. Having had privileges that their own mothers weren't entitled to must have been awkward, to say the least. But the benefit of being mixed in a small colonial society is unclear now decades later when Nanny has no special story to tell about her life since she left and Antonia's Saint Bernard roaming the grounds of the house supposedly to protect us is as old and near-sighted as she is. Her kitchen's ant infested. Her roof has been blown off countless times by countless hurricanes and been haphazardly puzzled back together the same as everyone else's. They're almost too well-mannered to speak but conspire in the tones of parishioners some-times when drinking tea.

"Begonias," Antonia says.

"Navy blue," Nan agrees with the resolve of a fi-

nal brush stroke. The Brathwaites. The Griffiths. The Fishendens. Nanny only socialized with other small islanders in the U.S. Her most intimate views of America she's gotten from watching television, but here back home, she seems just as out of place.

Men, tall, long-limbed in guayabera shirts with pleated pockets and smiles that low-key bling collect us in English compacts they steer around high narrow cliffs we'd easily drop off the side of if not for their extraordinary patience and common sense. Relatives who know who we are but not vice versa offering me tea or cold bottles of Bryson's, a soda with a bubble gum taste. I should rest a broomstick across my back and wedge my arms under it to improve my posture, one recommends, which I try when I'm sitting on Antonia's veranda once but the fact that I'm wilted doesn't really concern me. Deep in the tall grass along a desolate route, boys shirtless flat and smooth as Gumby tease rhythms from rusted oil cans that rumble secret signals. It's a covert sound that must have made the devils who ran the sugar cane fields lose sleep, is definitely not cruise ship music. Mongoose are eating our chickens, a cousin I've heard about all my life due to his active role in domestic politics says when we lounge outside in a row of chairs, and I recall Granny saying that there used to be snakes in Antigua before mongoose ate all of them, but I never sight one of these formidable little creatures. So many relatives I lose interest in knowing their names. We take a cab up to Parham where an old woman with a familiar face but who I've never met is hacking wild grass with a cutlass.

She and Nanny speaking only briefly. Nanny handing a fistful of cash to her and bidding her farewell, then we're riding back to Antonia's again without any discussion about who the woman was to us. Rough black sand full of drift wood and broken shells one of my cousins rests a bed sheet on top of at the beach before munching on smoked herring and falling under the trance of the Old Testament spread across her lap. Tourists don't come here. Too many locals chilling out as if in their living rooms, wearing everyday gear. No bikinis. My sister and I are independent. Thwacking a volleyball back and forth across a net in a dirt lot with kids who go to Princess Margaret School. *Liming* with boys I make friends with who whisper scandalous gossip in my ear about random people we pass when crossing Fort Road. Milk shakes made from potent local "figs" that haven't been disinfected and refrigerated ad nauseum that I wolf down at a spot called the Golden Peanut. Antonia has poor eyesight. The plates of food she serves are always crawling with bugs so my sister and I opt for the goat roti with sharp bones in it in a dive run by a Guyanese family with a lonesome son named Adam who neighborhood kids call a *dugala* in mocking voices.

Easter is with the same cousins we hung out at the beach with who live in a shack near Market Street. "Tie it with string and 'bwoil it like so," one instructs. We wrap balls of cornmeal and coconut inside banana leaves tugged from a tree outside the kitchen, eat, then walk to an open-air theatre designed in the style of a colosseum and sit on wide vegetation overgrown steps. The trailer for "The Great Escape" starring Steve McQueen,

a movie that came out when I was three years old, has everyone on pins and needles. Go figure. Dino De Laurentiis's "The Bible" is not exactly a new film either, but is the main feature.

"Don't eat the apple. Don't eat the apple," a man in the audience keeps shouting at Eve as if Eve's a woman who can hear and not an image on a screen the same way Granny used to shout "Look out. Look out," to the TV detective Mannix when he was in danger. Days later, we step out of a cab in front of a manor house that's now a government office but was once the home where Nan was raised, Nanny simply standing with her hands at her sides observing it politely whereas Granny would have grabbed me tight by the wrist and begun to reminisce.

"Don't worry it won't rub off." I remember Nanny telling a white woman basically the same complexion she was who scooted over to make more room for her on a crowded bus once. The woman, who didn't get why Nanny was offended gaping back at her in confusion after Nanny, failing to prove that she looked like the "blue-eyed devil" but wasn't just sort of cringed. When she, mommy, Aunt M, Aunt D and Granny wanted to move into a certain building that in spite of it being illegal, didn't rent to black people, Nanny was the one sent to fill out the application and sign the lease. Once the tenants realized that blacks were suddenly living among them, Nanny was the one they were especially outraged by for having deceived them. Mommy liked to brag about it because it was a battle they had won against a bunch of bigots, but the thought of Nanny having to walk a gaunt-

let of hostile neighbors everyday sounded so awful in light of knowing how timid she is. Coming back home with her was supposed to have been a happy ending, but when she's eyeing the once fine colonial dwelling where she grew up, I sense something heavy on her soul that there are no words for.

9

New Rochelle High's the school you see in TV shows and movies about all-American teens. The Gothic spires. The sports field and footbridge outside the main entrance thick with all sorts of kids. What enables me to go to a public school in a town where I don't live: A lady my mother worked with years ago whose number she looked up in the phone book.

"You will be using a false address," mommy announced after she hung up, making it sound like the highest distinction. At the same time warning me not to let anyone know where I really live. But if there's a downside to being marginalized, I'm unaware of it. I've kind of had a boyfriend. Plus, I'm developing extra-sensory perception, which is why the first time I run into Parnell, I know we're going to be besties. It's 1975 and cool boys rock marshmallow shoes and the precision cut 'fros of Ultra Sheen pomade models in Jet Magazine, but he has on battered wingtips smeared with white polish. His hair's short and nubby. His striped shirt doesn't match his plaid bell bottoms. He's flipping the bird to everyone who's got the latest look down even if I realize that it's by accident because it's clear he just arrived.

He's surprised when I use a few words of French Kreyol I picked up in the lunchroom where five, maybe six different languages are spoken any given day. He's going to the ESL program in the basement, the paper he shows me says. No big surprise that he can't find it. I gesture for him to follow. You would think it's sweltering. It's not, but he mops his face as we walk. The scent of his

hankie somewhere between a fresh baked brownie and the water left in a vase after the flowers that were inside it have died and been thrown away. If I inhale enough, I imagine I could get high on it. My nose has a brain I should add because few guys whose sweat glands are raging smell so good.

We communicate by reading each other's thoughts and faces. It's funny he relies so much on me of all people to learn his way around because I know only slightly more than he does about this bigger than average small town we're in that at some points is pure Sally, Dick and Jane and at others a no man's land of boarded up foundries. As far as his determination to become popular is concerned, it's hysterical he thinks I can be much help with that either because he considers the remote part of the basement where students in the English as second language class congregate a social dead end, but there are days when a floor of the school just for kids who've been uprooted and are reinventing themselves is exactly where I fit. But I enjoy being part of his evolution from a newcomer lost in the hall to a homeboy using the same slang everybody else does. Before Parnell, I looked after an Eritrean with the most elegant way of lighting a cigarette between classes as well as a Burundian whose father had something to do with the UN who hadn't seen the point in getting to know anyone because he never stayed around in the schools he was enrolled in for long. Using French was the Burundian's preference but he was fluent enough in English to tell me about the kids at his last school in Saudi Arabia who had asked if he'd ever eaten from a plate or used a knife and fork. He must

have found being talked down to especially infuriating. He was so comically uppity, The last time I saw him, his sister, the tallest teenager I've ever seen, was cat walking beside him with a headful of Hellraiser braids towards the private driver who picked them up at the end of each day.

But Parnell—he wouldn't exactly be lonely without me. He has homeboys who also just arrived in the U.S. that he can be himself with. I see them sometimes in the teacher's parking lot tugging along girls in pleather jackets and wobbly high heels that just arrived from Portugal and Italy who flip their bangs so much it's like they have a nervous tick or something.

All that said, not until the summer after the end of sophomore year do Parnell and I spend time together outside of school. He's never been in the subway, and what an intense day to be underground for the first time it is. The train lunges, then brakes without the slightest subtlety as more and more people with features I recognize and others whose backgrounds I strain to guess, step on in t-shirts with the flags of the islands they're from on them until the whole car is packed with riders from countries that unless most people are planning vacations, forget exist, and we're either guests at a get together in a graffiti bombed apartment or passengers on a chicken bus minus the live animals. Take your pick. It's Labor Day. Usually I would have a heavy heart about the advent of having to wear socks weather but listening to Ken Williams on the radio earlier live from Eastern Parkway, I sensed something out of the ordinary was taking place and had to be part of it. Caribbean baker-

ies and travel agencies sponsoring a massive street party on one of the biggest boulevards in the five boroughs. New York had always had ethnic parades. J'ouvert celebrations held in rented ballrooms. I'd heard my family talk about them, but I had never been part of a West Indian gathering that people who weren't West Indian could see. Granny did her "marketing" for things such as coconut, mango, salt fish and "alligator pear" in tropical markets back when I was younger. She shopped where people from Spanish speaking islands shopped back when black and foreign was impossible to reconcile and black friends whose family traditions went back to early America could make you feel like a total deadbeat if the song of the South were absent from your voice. Anyway, what I think of once I'm beset with the bright colors, drums and dancers exploding from the dismal concrete vanishing point in the distance is a blizzard of cherry blossoms. All my mind will return to later, however, will be Parnell guiding me through the merrymaking with the tips of his fingers barely touching my waist as if I, of all girls, were a precious vase that might break.

10

La Loca de Puerto Rico and I lost in the delirium of the salsa playing. I'm La Loca de Nueva York. We introduce ourselves as Las Dos Locas to random kids in the hall at school when we're feeling extra silly. Willie Colon, Eddie Palmieri, Conjunto Melao and Fania All-Stars albums gutted of their discs scatter the stereo. Two Latin music addicts inviting chorus after chorus of our favorite songs to devour us whole.

La Loca de PR recruited me to dance to "El Numero Seis" by Bobby Rodriguez for the All-Culture Week school celebration. The group she was in had more guys than girls. Stumbling through the halls in high heels, a little black dress and eye makeup I had mixed feelings about letting mommy put on me, I expected to be laughed at, but kids who weren't part of the event just seemed curious more than anything else. The Colombian boy a grade up who was my partner, spinning me by the hand ever so cautiously. Mommy showing up at school on the rare occasion that I wasn't needing her to bail me out of trouble, anxious to watch me perform, but she was around my age when she learned how to dance to La Lupe and Machito.

Iris Chacon hip wiggling in glittering sequin dresses. Hammy telenovelas. *Si es Goya, tiene que ser Bueno* commercials looping in my head. You have got to be totally out of it if you're from New York and don't speak at least some Spanish. It's the lingua franca of almost

every storefront. The choirs of men singing to knocking claves and hand drums in the park. Not to forget the *Jíbaro* couple selling tropical icies from a wheelbarrow on a busy corner where I was unable to figure out which way Fanny and Granny went, assuring me in Nuyorican baby talk that I could live with them. New York also has lots of lines you're not supposed to cross, so the fact that I consider Latin music a part of my culture might rub some the wrong way. But Aida gets it because congas are pounding, and a cowbell's keeping time in some of her first memories too. Her family's from the Bronx, so even though she lives in a fairy tale green house inside a white picket fence you curve up a hill past Ossie Davis, Ruby Dee's and the Farrakhans to get to, sometimes she just has to go back to her childhood stomping grounds and let the spicy amber grease of a hot *pastelillo* stain her clothes. Her dad's a civil servant like mine. Her mom's Jamaican with enough Arawak blood that a Tahitian woman in a Gauguin portrait is what she calls to mind. The Latin Percussion timbales in the den that belong to her older brother are an apparition of my father's red sparkle Gretsch kit. She has cousins from London too, but that's when what we have in common ends. I can just show up on the fly, lounge in her kitchen and watch how artfully she runs a spoon around a pitcher of this powdered cherry drink she squeezes concentrated lime juice into as her parents and siblings stream by at the beat of characters in your favorite sit com. Whereas I enter my home with my head down and avoid areas where I think I'll run into anyone else.

Kids getting learner's permits are suburban rites of passage my parents are oblivious to, but I like walking. Plus, being sealed in a car would be way less enriching than the supposed inconveniences I'd transcend. I cross a section of Eastchester that touches Bronxville that will take you right into New Rochelle or follow Lincoln Avenue through the town of Pelham. After school, doing the same thing in reverse. Drivers and passengers scrutinize me when they idle at stop lights. Walking isn't normal behavior in the burbs. But I don't mind being watched. I look right back. There's a bus I see sometimes parked along some woods I walk past when heading home in the afternoon. Doors closed. No passengers. Only a driver with a salt and pepper beard and a soiled bandana around his neck who uses the same bebop inflected code as my father's co-workers when they'd mount our patio chairs like thrones during summers when mommy was still entertaining.

"You don't have to pay nuthin, baby. Get on go ahead," he told me the first time I boarded. I thought maybe he was up to no good, but more kids he treated like nieces and nephews got on, slapping him five and filing through the aisle minutes later, so I ride with him on the regular now. He snacks on M&M's, listening to Ramsey Lewis's "Sun Goddess" on his tape deck without stopping to pick up anyone else and nothing could be more 'smoove than being young and black in Westchester than when the bus is pulling off, and I'm on the corner of North Columbus Avenue with my arm raised to him in salute.

Stephanie Mills owns the New Orleans style house hidden behind high hedges across the street. She's still on Broadway, playing Dorothy in "The Wiz," the R&B version of the Wizard of Oz that as soon as it opened, Aunt M took me to see. Ralph McDonald, the songwriter and percussionist, recently bought a home down the hill. Black actors or musicians—that's who tends to be our new neighbors. It's rare that you step outside and see any of them, but just knowing they're around, as corny as it sounds, can give you a positive outlook. I've always considered success a readymade circumstance that would suffocate me—the total opposite of being surprised and fascinated, which is my preference, yet little by little I've been becoming inspired by the most commonplace events such as the gathering that took place at a park in New Rochelle a few weeks after I'd completed my sophomore year. Aida had phoned a couple of hours earlier. She had just found out about it herself. There was going to be a DJ she mentioned. A lot of people would be there she had also said, so I told her I'd meet her and went on foot because I walk miles at a time easily. I could hear the music even before I arrived. Kids from surrounding blocks and other towns converging out of curiosity. The DJ had a light touch. Simply dropping an Ohio Player's record on and letting it drift. I would have been slow dancing to "Honey" with some silhouette in a sweater that reeked of ripe cherries, a slow cooked soup if I had been at the usual party in someone's basement, but in spite of us being on a street with a steady stream of traffic, I entered a lucid dream of boys I recognized and others I'd never seen with lavish 'fros and regal shoul-

ders. Boys the complexion of caramel, cocoa, flan, cream soda—all my favorite flavors eyeing me back or checking out girls they preferred as we spread out over a plain of turquoise grass roused by an early evening breeze. Aida smiling so brightly each time she told me who was related to who, since last names carry so much weight among us.

"He's a Faison. She's a Flowers. You can tell, right?" She'd chuckle. Nobody danced. Not the slightest hint of reefer. No police cars. No gunfire. No conflict. Maybe the most eventful thing that happened that night was that Aida and I pieced the whole black diaspora together again, but it was a time when I was beginning to like school.

"Organize your moods into the colors where they belong, Jennifer. You can do it," is feedback I receive on a creative writing assignment when I'm in eleventh grade. Comments in the margins of tests and papers, I've never given the time of day to that I've begun to read lately. I'm in a couple of advanced placement classes, one being Spanish where I'm reading untranslated texts. Borges is a prankster whose playfulness grows tiresome quickly. I prefer Lorca. *La Casa de Bernarda Alba*, will be the closest I'll ever come to finding the devoutly tortured women I'm being raised by between the covers of a book. When characters I read about have lives that resemble mine, the less isolated I feel, and having had more in common with Kafka's roach than I did with Bigger Thomas, I'm grateful to Lorca for offering me what Richard Wright didn't. I learn the word "vicissitude" preparing for the

reading and writing part of the SAT. Indifferent math and science instructors writing across the board the whole time with their backs to me is a slow savage death. Numbers lack empathy, are always at the service of formulas that reinforce indifference. But the bottom line is I'm getting better at playing the whole musical chairs game between classrooms.

Doing homework is optional. Mommy never asks about it. As long as I wash the dishes, I'm good. No one's encouraging me to do much. But I'll find mothers elsewhere. Most of them will be men, but one will be Femme Gang. The first time I see her, she's flying, the cashmere sweater draped over her shoulders flapping behind her through the air. Pressing a calculus book to her chest the way you'd calm a cranky baby. She won't be the only A student I'll meet, but she'll definitely be the most intense. Always in a rush to get to classrooms where clubs, a couple it seems she's president of, hold meetings. I get to know her once I have enough nerve to sit at the *boojie* table in the cafeteria. *Boojie* being what black girls whose fathers aren't lawyers or doctors call them, only saying it to be playful without any real disrespect intended. Not once do one of these so-called "boojie" girls bring up the hush hush network known as Jack and Jill I've heard they all belong to. Maybe it's a case of Eskimos not having a word for snow. Lawrence Otis Graham's book, *Our Kind of People: Inside America's Black Upper Class* hasn't been published yet but at some time in the distant future, I'll snoop through the who's who in Westchester parts of it until the page is not even there and see

Femme Gang at a crossing we've reached after walking for a few minutes in the same direction.

"Which of the two routes I can take from here do you think will be the fastest?" I ask thinking out loud.

"The shortest distance between two points is a straight line, right?" replies Femme Gang like she's puzzled.

"Oh math. It's for neat freaks. A form of tyranny that tries to make counting coins prosaic," I explain after which she observes me like maybe I'm not real and she needs to get more sleep. I'm sure she thinks I'm strange and I don't expect her to want anything to do with me past then, but I become a guest at a string of parties where boys have King Tut eyes and curls the size of grapes and "Harvard, Harvard, Harvard," are the lyrics to every song that plays, not getting how I came to deserve the privilege to be at events where everyone has been so meticulously handpicked. My slouch and legs that dangle forever creating the illusion that I'm elegant maybe.

Everyone has an inner circle. Everybody's a snob in their own right, so there's absolutely nothing about Femme Gang or her friends that I'm critical of. In fact, if not for her go-getter influence, I wouldn't have felt so certain that continuing my education after high school was what I should do.

"A degree is just a piece of paper," is how my mother has always put anyone she feels is grandstanding back in check, so the ride with her to a college where I happen to have an interview. Well. There's not a lot to look forward to, I'll just say. It's the fall of my senior year. Traffic

thins fast when you're not heading towards Manhattan. Trees extend their fingers as if trying to grab back their leaves. We started out early. You pass a farmhouse, then another doesn't appear for another 15 minutes. A man in a pickup truck crawling next to us, giving me the same look I imagine he gave the deer tied to his hood before he shot him.

Aunt May completed an associate's at a community college once she had a little less responsibility for Nanny and Granny, keeping her life as an adult student to herself a kind of survival strategy, and no one ever really talks about it. But Pamela, the distant cousin in a picture in one of our family photo albums that goes back almost a hundred years, she went to Oxford. I know this because I heard "Pamela went to Oxford," a lot when I was younger. And oh how they'd say it and because all that has ever sustained our tiny family is the past, when mommy points at cows that appear on the roadside or stays quiet instead of asking me what I plan to study if I'm accepted to the school where we're heading, I can tell she's not ready for old Pam to get knocked off her pedestal, least of all by a pipsqueak like me.

Columbus couldn't hold a candle to Mommy and I. We have only the vaguest idea of where we're going. The earth is flat and we're close to falling off its axis even before one of our tires blows out along a deep ravine. Some reticent highway patrol officer with a ball of tobacco in one cheek will crawl by much to our relief. We'll flag him down before ending up in a diner next to the garage we're towed to where the jukebox will stop as soon as we enter and diners with steel bats for faces will deadpan us

over the tops of coffee cups, timing each minute until we leave. The more pristine the scenery gets, the less safe I feel. But I'm getting ahead of myself because our car trouble won't begin until we're on our way home, which is almost as soon as we arrive for my interview. There are only about twenty liberal arts colleges worth going to in the United States. We're coasting towards one of them. They tend to be in the northeast. Just saying their names can make you lose your head. The college bug I'd been bitten by at school, I have no idea where it went once we arrive. I'm supposed to get out of the car but am too freaked out to, especially with mommy acting like I already left. Picking her teeth with her pinky nail in the rear-view mirror as if I went to buy a sausage and pepper calzone and will be right back. All you have to say is "what have you got to lose?" and I'll pretty much try anything, I'll realize about myself much later. I don't need to have my hand held. Just call my bluff. That's it, but my mother makes a U-turn back out of the parking area without losing her temper or seeming to mind that we drove so far for absolutely nothing, just focusing on getting back to Westchester before sunset once it's clear that I want to leave. I'll simmer in resentment the whole ride back, not getting why she hadn't encouraged me to keep the appointment and get some advice on how to turn the scribbles I make in the margins of my textbooks into a specialization. But the reason I think she didn't is mommy the feisty daughter who goes after whatever she wants, unlike Aunt M., is a myth even if she always triumphs in the stories she tells about her confrontations with old adversaries like the receptionist

at a chic ad agency on Madison Avenue where she was supposed to have had an interview when she was younger who told her the job had just been filled. Mommy smelling a rat, going downstairs to a phone booth to dial the same woman again to ask if they were still accepting resumes being told, "Yes," then lunging back into the office to threaten the bitch with a discrimination lawsuit and taking delight in watching her cringe. Mommy finally losing her temper with other black girls in school ever tugging at her hair to see if it's real and threatening to chop it off with a pair of scissors. Mommy reporting the teacher who asked kids in her class to share stories about their parent's journey to America but wouldn't let her take part in the discussion because she thought immigrants could only be white people. Mommy hocking vulgar words right back at the stunned Romeos crudely catcalling her as she walked through her neighborhood. In some of these flashbacks my mother's victorious. In others, she walks away feeling derailed without ever quite admitting it. That she chose a diploma in secretarial studies at the end of high school instead of deciding to go on to college when her honor certificates, student council awards and *certificat de merite* in French almost fill an entire photo album—speaks loudest about how helpless she is. Being raised in a home as insular as Nanny and Granny's, she never really knows what she's doing, and I feel responsible for helping her understand how things work. Then, roles get reversed between us, which has its moments but always ultimately ends up just being a drag.

A week later, in spite of how torn inside I still am, I'm on a second college campus in Connecticut. Mommy gets out of the car this time, only we're unable to find the admissions office and are lost when an African-American girl with flawless posture and hair in a Nubian head wrap offers to help. As soon as we begin to follow her, however, she recommends that we stop by the house where she and her roommates can give us their personal opinions on the school. Mommy, who has always thought spontaneity is a virtue, is glad to be on her way for an impromptu sit-down in one of the charming stone houses she's been smiling at since we drove in. Nefertiti has something heavy on her mind I notice. As soon as we're trailing behind her, falling silent. But once we're inside and seated in the two chairs they position side by side for Mommy and I and they're perched on taller bar stools speaking down to us, it's clear that they don't have time for small talk and I realize I've been tricked into attending a panel discussion of girls with melodious voices, Swahili names and the poise of the classically trained. They're members of a student organization at an impasse with the college administration they explain. Mommy has no idea what they're talking about but doesn't need to, simply nodding in time with anything they say that sounds indignant. I was hoping they'd ask what I'm interested in studying, invite me to look at the many books on the shelves that take up an entire wall of their living room or offer us tea. Each minute that they don't show the slightest bit of interest in me personally, me trusting them less and less. Nefertiti says she's trans-

ferring out without revealing where she's going or what her plans are next, slumping with a distraught face for a second, but I'm not the slightest bit in suspense about what the future holds for someone so self-possessed. I'll meet her over and over again in different contexts. Well, not *her* per se, but a type, a type like her whose life obsession is to win the imprimatur of the very institutions that torture them. Hooking their status conscious credentials onto edgy personas and militant rhetoric once the committees that have dogged them out for the best part of their lives set them free. I should apply elsewhere to avoid the struggles they're up against they advise me and my mother in summary. I'm young. My mother is naive so we express our solidarity with their cause by thanking them for stopping us from wasting our time, then I'm back in the car and on my way off the grounds of a second college without so much as doing a tour, never mind an interview.

But we do one more college visit, my mother and I, this time to Philly by Amtrak, taking another train to a small sequestered town along the Mainline as they call it. There's more land than students there. We cross a field. No matter how much you walk, nothing changes. There's just more of the same thing. A stone house I imagine is a dormitory. "Look," says the student coordinator pointing and smiling at something my mother and I strain to see but can't. A rhombus shaped cube that seems out of place between such pristine architecture appears. Walking and more walking until we see the admissions building and continue towards it. Dead leaves and their tiny bones snapping under our feet just like

mornings at the selective prep school I went to. I was so cold and lost there. "Autumn sets fire to everything. Relax. This will be different," I sweet talk myself and finally survive an interview. Nobody applies to only one college. But I do. Documents I get signed and essays I write because what the hell? Just do what's asked I think, going to the post office, mailing it in. Back to dogs barking, slamming doors, the cries of two people deeply suffering followed by periods of quiet I don't have faith in. I can hardly hold a fork or tie my laces. My hands are so unsteady, and don't let a balloon pop, I'll physically act out the noise it makes. Other girls at school find it amusing, but I'm a nervous wreck.

I was in the parking lot the previous Spring when a teacher with two Bozo the Clown splashes of hair at either side of his head, but bald otherwise, who I'd seen in the ESL class before, shuffled my way. He's going to tell me not to lean on his car I figured by the look on his face, but he began to speak in Slavic accented Spanish, cautiously keeping his eyes on me the whole time. I would have done anything to have heard the discussion that led him to hunt me down in such desperation. He had always felt Russian should be part of the curriculum he said and he'd be approved to teach it if he could find just one more student who'd be interested. That teachers in the language Department had recommended me to him because they thought I'd be able to handle one of the most difficult languages for English speakers to learn was flattering at the same time that I was paranoid about my name having come up in spite of my determi-

nation to keep a low profile. Now, it's senior year already. Spring to be exact and twice a week, I sit at a desk in the back of his class bored shitless.

Ya izuchala russki yazyk f shkolye, I'll remember the rest of my life, though that and certain letters of Cyrillic script will be it. One Russian word can kaleidoscope into countless different shapes depending on what other parts of speech it makes contact with. A language nothing like English that nobody speaks in the hall of the school would take forever to learn I figure, so stop paying attention to the conjugations on the board pretty quickly and just lose myself in the view of new grass and cars coasting Main Street. Most of the desks are empty. The handful of others are honor roll students in Izod vests and pricey tennis sneakers who belong to the local country club, but are the grandkids of refugees from Minsk. I know this because the teacher went around the room to find out why each of us had chosen to sign up for his class, of course skipping me and another girl who tends to sit slumped in her chair reading Patti Smith's book "Babel," who may have also signed up for the class as a favor. I don't know. Stringy strings of scattered hair. Saggy pants and washed out flannel shirts she drags along in. Her name's Lilli. She's always either sleepy or pouting. Things have fallen apart at home to an extent that only the most sarcastic lyrics can express, so for the first time since fourth grade, I'm listening to rock 'n roll again. Lily and I in her parent's wood paneled station wagon where she blows smoke in even trails out her nose and when I tell her how cool it is, here, it's easy, she says, giving me her cigarette. Tears torching my eyes when I

try. I cough, promising myself to buy a pack and practice in the mirror, which I do once. She's going to film school. I'm on a dead end now that I realize my plans to do what my classmates are were unrealistic. Tugging an envelope addressed to me free from the bills jammed in the mailbox come June though, I discover an acceptance letter from the one college I applied to. The same school the valedictorian of my graduating class mentioned had also accepted him. Unprepared for a happy ending, of course, I panic and figure they must have made a mistake. Calling the number on it and asking if they did. But "You've been selected. Why yes," a lady says before I go back to looking at the letter in my hand again in secret for many days without ever getting how such a cautious looking document could have my name on it.

BLUE

11

It's a few months after Nancy Spungen was stabbed to death at the Chelsea Hotel where on a recent rain-blurred night, he slashed his finger with a razor and painted with the blood. I know it sounds crazy, but I'm 18, and he's older and kind of mentoring me like when I say I want to kill myself, and he says, "If a guy in a Winnie the Pooh mask were chasing you with a sledgehammer, you wouldn't." His name's M. He's from California but the longer you've been in New York, the less you know about it, so he leads the way in a faded army coat that's way too big and me in a cigarette burnt sweater I just bought for loose change at a store called Revenge, freezing as we weave east on Astor Place into the brave new world he described when we'd roam the pristine town around my pristine little freshman dorm. Doing gravestone rubbings at a favorite cemetery. Saying his parents were "pushing daisies" without explaining exactly what that means. The night I followed him to the room he rented off campus was slightly risky, but dude chalk-sketched with Devo and the Sex Pistols twisting in the background, didn't drug and dissect me, so ever since then, I've been his sidekick. Only it's hard to keep up with him sometimes like now as he shuffles with his toes turned in and arms flying towards the apartment of some girl he wants to talk out of becoming a go-go dancer.

A rust stained American flag is her living room curtain. Frozen orange juice containers what we drink

from. Kathy Acker, Zora Neale Hurston and Kafka share an ugly paint-caked book case. A hippie scarf draped from a lampshade. Records jammed into milk crates. Two slits for eyes and Ella Fitzgerald cheeks. She talks so smooth. She's black too, but I'm not sure what that means now that I'm below 14th. She returned from Paris recently where she was supposed to be an exchange student completing the final credits of her senior year at Barnard but spent all her time drinking at Les Bains Douches, Le Genie and Les Palais instead of going to classes. She traveled around England listening to new bands, getting paid for it as part of a job she got working for CBS France. She's from Detroit so I call her Motor C., though that's not her real name.

It's 1978. Wherever you are, the same ten pop songs play on the same few radio stations again and again, but at her place it's Public Image Limited, The Plasmatics, Television, ESG. I've never seen a pink vinyl record before. She met M. for the first time at a club somewhere nearby and that same night, he crashed on her sofa. I can't imagine her doing naked splits on the stage of a bar with blacked out windows, so don't understand why M. thinks he needs to save her and if he does, how just sitting there without saying much is going to do the trick. Motor C says I can play whatever I like. I put on "Roxanne" and am resurrected. It's only my second time drinking beer.

"Roxanne, Roxanne," the Police are still chanting—at least in my head—when M. and I step back out into the starless night. Car blinkers dim and whatever was there a second before gets deleted. It's so cold, I can taste it. M. shuffling into the invisible distance with the usual po-

lite indifference when I least expect it, but I'll bump into him in the future. Once, in front of a walk-up near The World Trade Center where he's renting a studio without a bathroom. He'll invite me upstairs and we'll crouch on either side of a freshly smeared unstretched canvas of his chuckling like he got away again with doing something he shouldn't have.

"I thought you guys were together," Motor C says when I swing by her place on St. Mark's and First the following weekend.

"And I thought the same about you two," I say, not fully grasping why either of us would want an Egon Schiele portrait come to life for a boyfriend. Motor C is a social butterfly. Motor C is also a recluse. Calling 411 operators "ma'am" one minute, out-of-tune guitars sweeping her off her feet the next. She's tough to read. You'll never find anything in her frig but the same petrified slice of pizza, but she keeps an impeccable rolodex full of cards scrawled with the numbers of Jello Biafra, Fred from the B-52's, and other key contacts. I don't want to seem needy, but I ring her buzzer all the time because I can't get enough of life in her post-apocalyptic shrine. Lucky for me, she lets me in, which remains the case no matter how early in the morning I ring. Sometimes her apartment door's already ajar before I enter and she's stumbling towards the red bulb burning in the innermost recesses of the hall without even checking to see who's there. She hibernates, doesn't sleep, the fact that she shares her personal space so casually with people she barely knows part of her mystique.

"Me I Disconnect from You" and "Trans-Europe Express" are songs I lose myself in when Motor C's not around. I've taken *Sleepless Nights* from the shelf once or twice and have read a page or two of it. Elizabeth Hardwick's an important writer who has something to do with the manuscript on Motor C's typewriter, so I'm extra polite to her when she calls.

I have a key, which is simply miraculous being that I'm a just a freeloader who eavesdrops on the clandestine discussions Motor C has with friends almost invariably dressed in black that file up the steps. Jim, a filmmaker with hair flung from a paint brush. Nan, a photographer whose name carries more weight than others. Viv, an Irish girl with a Super 8 camera. The Saint, a writer who dresses like a Parisian intellectual of a bygone era. A singer with a joker smile named Cynthia. Barb, a free spirit who plays keyboard. Not to leave out the brother in the tilted beret who tends to sit on a plank of wood across the radiator in eyeglasses so opaque that I figure his view of me is unreliable enough for me to trust him. Barely out of college and already being published alongside Didion and Sontag. He doesn't quite talk. He purrs, then offers inviting silences that encourage me to say something. Soon we'll watch "Vice Squad" together in a shabby theater that only shows B-movies and explore our odd electromagnetism in bed.

I'm a fugitive hiding from my real life while the French kids who show up to take showers and catch naps on the floor are broke bon vivantes. A boy Motor C. only

sort of remembers having met in a London shebeen. I couldn't name all the people in and out of her crib if I tried. Even her super, Gonzalez's brother, pops in when he's not doing drunken Tai chi between Bellevue ambulances roaring up First. I mean Motor C.'s hard-assed couch is such a sought-after place to spend time on, I'm lucky each time I wake up on it.

12

Boomeranged back home after only a semester, but mommy's forgotten all about college already. I'm wiping the puke from my jacket after a night of heavy drinking, and "I envy your life" she sighs, but she's not the mom from "Leave it to Beaver" with the fresh baked cookies and pitchers of milk. My father's not the dad from "My Three Sons" palming a Winchester pipe in deep contentment. Sometimes I just wish they were, as dumb as that is.

Working part-time at Waldbaum's near the Fleetwood Metro North station. All I had to do was arrange jumbo boxes of Sno-Caps and Goobers evenly on the shelves at first. Halloween and Easter are the only seasons anyone really visits the candy aisle though, so recently Carmine, the manager, gave me a blue and gray cotton jacket with my name written in cursive letters on it and walked me up front. No money handling skills. Hate operating machines. If there's a bright side to being a cashier, as opposed to a student on some rustic campus kids who graduate at the top of their high school classes end up, it's that my family seems more relaxed around me. A community college would have been cheaper, Aunt M. will later say, and having been called a know- it-all more times than I can bear, I'll be all ears.

The Georges are a larger than average family who live near us. Recently, instead of just watching me from afar with the usual wonder, the oldest son asked why I didn't

listen to the same jams as everybody else. I would have been wasting my time to talk to someone so out of it, so just blamed his lack of enthusiasm for Hendrix and Bob Marley on Soul Train and black radio being so stubbornly polite. But none of that has anything to do with two of the George sisters appearing in my line out of the blue. I'm sure that my mother, who finds it amusing, told them that I give groceries away for close to nothing. The first time I didn't mean to. Items were whizzing by on the conveyor belt faster than I could ring them up, so "Don't worry about it," I told the customer. But I liked the robbing from the rich thing so much, I started giving free stuff to almost everybody, so when the George girls put pork loin, some steaks, a leg of lamb and a few gallons of orange juice into their bags, then timidly eyeball me for the verdict, "A dollar's fine," I say under my breath.

I'm in Waldbaum's parking lot during a 15-minute break and restless, so drift into a boutique with a grand opening sign in the window across the street where a twenty something guy and girl with determined not to be sad faces watch like they're shocked to have a customer when I roam in. "Ca Plane Pour Moi's" playing on the radio. I sift through clothes on a rack, murmuring "Ca plane pour moi moi moi moi moi... " along with it without a clue as to what it means. Black walls, a disco ball spinning from the ceiling. It's hard to believe I'm in between Fleetwood Dog and Cat Hospital and Estelle's House of Beauty. When you're just one generation removed from the Hepburn era, you can ransack your mom's closet or thrift shop racks and be dressed to the nines. My ward-

robe is better than it will ever be, but I don't have any-
thing remotely like the tacky glitter pants I decide to buy.

"Studio 54 time," Ida remarks this Saturday that I'm
buying another pair in a different color that are firing
lasers at the glass as I look in the mirror. I know she's
just kidding but, "we should go down there and see if
we can get in," I say. The most blazing night imaginable
only half beginning later when I'm in their car because
anyone who drives to the city, doesn't fully want to get
there. It would've been so much better to take a cab to
the 2 train. They're fraternal twins. The sister drives.
Izzy cowering in the dark beside her. The highway's the
highway. Cars coast in procession. The river as startling
as anything not man made. Izzy says a married couple
that he's recently had three-way sex with wants him to
move in.

"My brother thinks he might be gay," Ida narrates.
They can't afford to cover the rent on the store they say,
taking turns as they elaborate. I'm the only customer
they've had Ida sighs and confesses, at which point I
lower my window and long for the freedom I once had
on the other side. We reach Midtown, but Ida's pained
search for a parking space of course kills the thrill of
finally having gotten where we're going. I don't know
why suburbanites get so bent out of shape when they're
somewhere without one main street called Main Street.
But they do. Izzy wanting to know if he should unroll the
sleeves of his jacket next. Ida giving him a once over like
a nurse before taking his blood, rearranging a strand of
her hair as he stands with his shoulders thrust back in
determination. Then, adjusting his glasses. I'm not an

"It" girl the door of every club swings open for, am just a newborn among New York's freak elite, but roaming the streets in silly clothes and makeup is as easy as trick 'o treating.

"We can go to Xenon's if they don't let us in," I say trying to cheer them up, not that it works. Reading the gossip rags near my register when I'm restless has made me forget that celebrities are human beings. Warhol, Deborah Harry. Henry Kissinger. I've got my eyes peeled for somebody famous to cut down to size with a couple of wisecracks when a limo pulls up, a man in high heels and a harlequin collar steps out, air-kisses the doorman and struts inside like he lives there. Nobody I recognize Oh well. Two men in pricey suits creep to the front of the line but are turned away. Soon money will buy everything, but luckily we're not there yet. Meanwhile, Izzy and Ida inch forward just shy of exploding into tears when a larger than life man in a suit gives me a fast once over, lifts the red velvet rope and finally I'm inside a once grandiose movie theater lobby ready to drink, turning to Ida to ask her to hand me the pint of booze stashed in her bag, I realize that she and her brother didn't get in, so vault towards the exit, but I might as well as be wearing my blue and gray cotton Waldbaum's jacket because the whole night's a bust—the low hanging fruit that detonates when you take a bite.

A woman squeezing pus from a pimple on her man's face as he combs his mustache with his mouth pointed down in pleasure are the only other passengers. I must look strung out on junk myself after hours of tunneling

in and out of dark warehouses off Canal with Motor City and friends. Nodding off in time to the train's steady shake and hammer, I'd hock my scotch and tobacco tasting tongue from my mouth if I could. I overdid it again. The girl that looked just like some lady on the cover of a pulp fiction novel waving us towards an iron door almost too heavy to open. "Neon Leon" somebody said under their breath when a flyboy with hot combed hair and penciled eyes ducked by in a hall of fluorescent tubes. Klaus Nomi. Suzanne Fletcher. David Byrne. I would've needed a "Who's Who of the Underground" if not for all the bios that were provided wherever we went.

"I can get us in," Motor City always says just above a whisper. There's no doubt she's got a gift for making bozos in charge of who gets in and who doesn't understand that the friends she shoves ahead of her may not be on the guest list but are coming inside anyway and furthermore aren't paying. She's privy to news only available to music industry insiders even if she recently quit a job she outgrew in the A & R division of a major record label. My thing is I don't ask questions, just meet her at the right time and place. Like the night she breezed a bunch of us into a Gang of Four gig only for members of the press. But tonight I'm blasting into the stratosphere of the 2 line instead of freeloading. I'll need cash to pay for a cab from the Bronx into Mount Vernon and don't want to wake up with my pockets picked, but Sandman's calling when my father's at the edge of the guest bed in one of the spare rooms that had become his even before it became official that he and my mother were ending their marriage.

"I'm supposed to start college in two days but don't have any way to get there," I try to explain. He asks where the campus is with more concern than I expect.

"Near Philadelphia?" I reply. He listens with a surprising patience once I begin to read mail from the college housing office to him, and I'm taken aback by the difference between him now and the antagonist I'm always clashing with. My parent's relationship—it's always been volcanic, but this quiet is not the usual reprieve between eruptions. It's over and he's devastated, and here I am planning to leave instead of sticking around to show a little sympathy. It's the second time in recent months that my mother has taken off for Jamaica where she has a clique of friends she party hops the island with. She's phoned a couple of times recently just to check in. I don't know when she's coming back and don't ask since it's about time she's had a little fun after the countless years she's been unhappy is how she would frame it. Pressuring her to come home to take me shopping for the things I need to bring with me would just rain on her parade. You'd think my father would tell me to get lost. I've always stood in front of her yelling insults at him without any reason to except that she was, but he reaches for his wallet looking worried, saying he can only help me get the essentials. Ma has the dream home she always wanted. A mink in her closet. There's never been a time when cubes of Chanel No. 5 or other stylish perfumes weren't on the wash basin between the custom powders, creams, brushes and pencils with which she shades and contours her face. Jewelry. I don't know much about, but she's sure got her share. She has her own car. Okay. It's

not the Benz she wants, but all my father does is work. He spends close to nothing on himself, is a prisoner of a life he just kind of endures, so I'm ashamed to be cleaning him out of what appears to be the last of what cash he has when I buy a roomy nylon hiking bag still not big enough to carry the many things I'm supposed to arrive on campus with. An electric teapot kicks out of the chorus line of my brain. I need bras. He waits with his head bowed as I rummage. Daddy can sit on a drum stool and shift from sticks to brushes. From the rims to the heart of the skin. Getting good at something takes humility. You can't be defensive. Mommy sets fire to things that require patience. But when we arrive in Philly, I wish she were with me instead.

More tickets.

We board a mainline train that rushes through scenic towns. Sitting side by side without talking, completely no-strings, and once parents and freshmen drinking lemonade appear on the grass at the top of a hill, he shoves a few bills in my hand and splits 'cause it goes without 'saying that he had nothing to do with this, and it's not like he's the type to make small talk under a welcome banner with the kind of overly smiling people he's always made it his business to stay clear of.

13

An organic café on Charles Street is where I ask for Hank, exactly as the line ad in the Classified section of the Village Voice said you should. Hank's the rotund man with mermaid hips and reading glasses dangling from a chain around his neck who it turns out I'm already talking to.

Oops.

He smiles, drops his head, bows and signals for me to follow him across a dining area where a spider plant fireworks across a window. I'm not in a Lower East Side storefront strung with campy Christmas tinsel. It's more some staged minimalist cover of House and Garden Magazine that's real. At a glass table with a vase of fresh flowers and two cups of herbal tea between us, I speak to him with a punky English accent that has, like the safety pins I fasten and unfasten from my t-shirts, become part of the process of doing whatever I want.

"Do you live nearby?"

"That would be great," I say, "but the rents are up there."

"Ain't they?" He fires back as if we've known each other for ages.

His wife is a scream therapist, he says as if I have any idea what that is. Our conversation drifts. A man in Birkenstocks whose beard could use a serious trim scans the menu as if it were a legal document and a girl I can tell is a dancer springs around the open kitchen on pointed toes.

You loop a long canvas apron around your neck, tie it around your waist and wash whatever they give you at a rusty metal sink in a sad tiny room next to the kitchen. I don't weigh much. My wrists are pretty thin. You could even say wilted, but I'm lifting a heavy iron pot to the sink when Stavros tells me to let it soak for a few minutes, so it'll be easier to clean. Stavros is the dishwasher that's leaving to begin a better job at a restaurant in Atlantic City, at which point I'll replace him. Me and a soft-spoken guy from the Bahamas studying dance at Alvin Ailey, we'll split shifts. Everything I'm doing inspired by the super of a building near our house in the Bronx where all the tenants spoke Papamiento. The chain of keys that jingled from his belt like a toy locomotive. His wife with two loaves of bread for arms sweeping the sidewalk by digging the broom into the ground and lifting it as if she were turning soil. The authority with which they'd remove litter and restore order to the small part of our block they were in charge of, had always impressed me. I want be like them when I grow up, I'd think, so I should regret having gotten what I wished for when I sweep in front of the café and keep having to drag heavy bags of garbage out to the curb, but I associate washing dirty dishes with freedom as funny as that sounds because once I'm running water around plates and glasses, the massaging motion of a soapy sponge and swirl of the drain take me on trips to better places.

Two disheveled collegial types panting with the uncertain elation of thrill seekers who have gotten a bit

more than what they bargained for appear and surprise me when I'm tossing water from a pail on the sidewalk after gook burst from a garbage bag I was dragging.

"We're from Portland, only in New York for a month, but no more money. Last night, we slept on a bench," one says.

"My name's Darren. You think we could find work around here?" the other asks. There's tree moss in his hair.

"Offer to unload crates from produce trucks outside restaurants," I advise. "Restaurants always get deliveries," I say as well as other stuff that might help them feel better before I go in the kitchen. Drop grapes, walnuts, tabouli and pita bread into a care bag, adding what's left of my cigarettes because we're all going to end back up in the places we're fleeing if we don't stick together this summer that you can buy two dollar valiums from a guy in front of Port Authority if you're too broke to go to the dentist.

The owner of the café who manages an all girl's rock band that dress up like Barbie dolls as some kind of spoof, arrives on her motorcycle in a leather jacket with lots of zippers, one day out of the blue. The storage area needs a good cleaning, she says, so that's what I'm doing when Ms. Hardrict, an African-American lady in charge of student affairs when I was in high school beams in front of me with the same troubled look on her face that she had when I told her that I'd been chosen by the head of the language department for the Latin American exchange program but didn't participate because I didn't want to ask my parents for that much money.

"The school could have found funds," she had said. "Why didn't you tell me?"

Because Granny's advice was to go in the kitchen and talk into the refrigerator if you had something to get off your chest rather than become the source of ridicule. Because even my parents, who once shrieked at each other at a drive-through intercom as "Welcome to Jack in the Box. Can I help you?" repeated, have always insisted that you keep the most agonizing details of your life to yourself. That said, I know better than to explain any of this to Ms. Hardrict. The storage area looks better. I'm done and staring into a twister of greasy water back upstairs when she's watching again.

"Why have you chosen to do so little with all your intelligence?" she asks, and I'm not going to justify what I do with my life to anybody. That's it. I reach for a bottle of cooking sherry to steel myself from her and any other ghosts who might barge in and demand I obey. I should stop after one glass, but am wasted by the time my shift ends. Shielding my eyes, using the same hand to wipe away the sweat. The ground swings. The sun has burst and Greenwich Village is bubbling in its fiery orange ooze. In a booth at the corner diner with a cup of coffee in front of me I don't recall ordering, I can't keep my head off the table. Jabbing at my tonsils over a toilet in the restroom. Sherry erupts from my nostrils. Out in the heat again, placing one foot in front of the other. Not getting very far before I mistake the pavement in front of St. Veronica's on Christopher Street for a bed.

"Sweetie, don't lay there," I hear someone who sounds like a waitress in a roadside diner scene in a Hollywood

movie say, only it's Bambi, a magical being with a ruby smudged mouth, mustache and beard who smells like she's been drinking a lot more than bathing. A homeless Vietnam vet who makes ends meet by providing married men who drive over the bridge from Jersey with sexual favors even if a lot of the time they don't have the good manners to pay her she says as well as other things I'm too drunk to process when we walk together to the bus stop on Eighth Street. Soon she'll sashay by with an extended wrist and all she owns in a dingy tote bag slung around it, and I'll make sure to give her whatever cash is balled in my pocket. But the next time I see Bam, I can tell she doesn't want to speak, then I'll never see her again, but we're glad to run into each other near the cafe that next day. The same day that I think "Uh oh. I'm getting fired for drinking all the cooking wine," when Hank asks if we can talk as soon as I walk in, but he wants to know if I'm interested in renting a room in the loft where he lives and with home being such a sinking ship, I do everything but give him a groaning bear hug for saving me from going down with it.

14

The statue of the Marquis de Lafayette in Union Square Park is buried in pigeon poop just as the grand Roman columns of the Bowery Savings Bank cringe in the scat of the live chicken market below. How it's possible to live in a bank, is a mystery, but we're ants that have turned a fruit pit into a nest. Me, Hank, his Swiss wife, a bosomy art school student and her black boyfriend Buck who struts around in whole outfits he obviously bought at Trash and Vaudeville coming and going through a door you wouldn't notice if you weren't looking for it. A cardboard wall is all that divides us from the bank vault on the other side. Chinese women that work in a sweatshop at the top of the first landing pad up and down the steps. In the fifties, during the bank's heyday, our living area was an office where secretaries in cat eye glasses hammered away at industrial age typewriters. The walls of a former file room that's mine for a fragment of the total rent are zigzagged with lead pipes. The floor's washed out and gives way when you cross it. Lights from the tower of the Empire State Building roam my mattress at night and tattoo every naked sweaty part of me.

And man is it hot as the tropics this summer of '79 that Motor C and a boyfriend of hers from Paris who doesn't speak English, and I avoid the heat roasting the city by taking blocks with trees. At the Broome Street Bar, Mister former boyfriend orders a tequila sunrise, then he and Motor C ask what I'm ordering. They're paying. Aunt M. used to give me a copy of Cue back before

it became New York Magazine and tell me to choose the restaurant where I wanted to eat after seeing a hit musical. Watching her squeeze lemon in her espresso after we ate, I'd always feel so special. I don't remember ever having celebrated my birthday other than with her, but all week, friends keep appearing to take me somewhere. A cafe with wood roller blinds adept at keeping out the heat was where I just drank green tea with a girl I only sort of know and her Japanese boyfriend who I saw perform once in a hairy eyeball costume with Screaming Mad George at Max's Kansas City. Climbing the steps of the bank to my room again, Epistemology appears for the first time carrying a box of books to another living space one flight up I had no idea existed. About Epistemology: He's the first person I'll hear use the word "epistemology" and the only one who will make it sound like the most mind blowing of all the Willie Wonka candies. I can tell by the stress lines that prism his face when I introduce myself that he's confused by something about me, but whatever it is, it's not too big of a deal to stop him and a buddy from inviting me out for dinner when I mention that my friends have been spoiling me lately and why. The three of us pausing and smiling as if catching a once in a lifetime astronomical event when we reach the corner of Grand Street where Greenwich Village, Soho, Little Italy, Tribeca and the Lower East Side intersect. Chinese and Italian signs blink out of time with each other. An old woman in a mandarin collar sinks her eyes into mine, and I'd give anything to hear her opinion. Men in belted pants who don't flick ashes from their cigarettes, just let wag from their mouths with un-

impressed expressions on their faces. Epistemology and his friend are English, in exile from some crazy making program at Cambridge where they didn't just read difficult writing, became possessed by it.

"Intersubjective communication," Epistemology says under his breath to his friend while I eavesdrop on their conversation without knowing what he means, yet sort of wishing I did because I can feel the gravity of it and know it's not B.S. Most of us are pushovers by nature. We'll put up with basically anything is how I'd summarize *Listen Little Man*. *Sex Pol* I don't know how to respond to and can only say that Wilhelm Reich has this Superman thing with him that I respect. But I read and run. Don't like research for the sake of it, cross referencing and the rest. Nothing's worse than getting stuck in a conversation with someone who mistakes having a great memory for thinking. Epistemology and his friend are part of a collective who made an academic sounding film about a Freudian case study that was reviewed in a recent issue of the Soho News but was way too dense for me to do more than graze. Epistemology refusing to dwell on his role in it now that I'm willing to take a stab at the whole premise behind it. Half this, half that with brittle curls and an irregularly shaped bronze face. He's beautiful in one glance and a bad drawing in the next.

Brass knuckles with tiny blades you can stick and slug someone with in one swing. Blood red pagoda phone booths. Rice paper lanterns and fancy ginseng gift boxes. Traffic dragging the length of Canal Street as far as the eye can see, practically playing the theme to "Rocky." The sun's not going down without a fight. We've had

enough beer and chow fon noodles when glitter arches in the colors of the Italian flag reappear. The aroma has become more fried zeppoles than wonton soup when there Hank and his wife are under a San Pelligrino parasol like a pair of newlyweds on the Riviera. They invite us to join them. Epistemology and his buddy taking a pass, but me unable to stop celebrating that I just turned 19 and grabbing a seat.

Mornings when I enter the secluded space upstairs where apparently he's the only tenant, he fries eggs and makes tea for us. Tugging a pouch of tobacco from his back pocket, dropping one leg over the other and smoking in thunderous silence as soon as we're done. I'm not animally attracted to Epistemology, but there's something about a man who has just cooked for you, and I don't mean the revenge that women take in having a chore done for them. I mean femininity and kitchens are supposed to go hand in hand, so women cook under social pressure whereas men have a leisurely way of moving around a stove that makes almost anything they prepare special. But he takes off for I don't know where in September and sublets his room to Dianne, a performance artist from Aberdeen who's an unusual combination of ethereal and grounded. We meet in the stairwell of course. Knocking on my door soon after she offers me a bowl of seaweed soup for some reason. I have no idea what I've done to deserve another neighbor so kitchen friendly, but the next day, she knocks again with more of it. One recent night so hot it was like I was melting, I had grabbed some scissors and started cutting my hair. Your

face could stop a clock, my mother once said in Granny's voice—without which she's unable to express certain opinions. "Good. I have a magic power," I had thought she meant. Working those blades, removing a lot here, a little there, doing a terrible job on purpose. Egging on my oddness. Prying stares coming almost as soon as I swept up the mess I made, usually coming from women whose successful careers were the best ideas they had come up with in the mood for something naughty, but I'm flattered if Dianne's flirting because there's something about her. Everyone's most electrified when the least happens at her sparse and introspective one woman shows. She's a real risk taker. Trekking through Tribeca before written records together watching the sun set, she points out sand dunes that look like pyramids in the distance. Bottles of stout we take our time drinking under the sky on the rooftop of the bank. Dirk is from Dusseldorf. Simone went to Camberwell and Ed will throw a cream pie at anyone for twenty bucks. She really knows how to introduce her friends. Wet hair, wet shoes, no umbrellas, Dianne and I reviewing the rain that has just soaked us through the dingy glass of a dining room where the only other customers are old men debating in John Cage composition sounding Cantonese.

I'm washing dishes still. The previous place was a storefront just below street level with a sign above that simply said "Eat." The Cauldron's my new spot. You can't palm a tea and read a book here in perpetuity. People always pressing their faces to the glass to see who's almost finished with their meal. The food's Kosher macrobiotic.

Yippies and Hasidic Jews co-own it. Servers, waiters, whatever you're supposed to call them, tend to be rude. During my entire dishwashing career, I'll only speak to a few. One who sold stocks on Wall Street before he decided to become a new wave star. Doing his hair exactly like Ric Ocasek since it was all about image, he said. Let me sleep on a loft bed in his apartment on Rivington when I was too tired for a long jaunt to the top of the train line and a cab to Westchester. Bought me breakfast and a latte at the Cupping Room on West Broadway the morning after. Now that's class. Robert, the pale hairless Mapplethorpe model was another perfectly standup guy who never lost his cool with you. Lee Ranaldo before I ever heard of Sonic Youth, and I will work at a vegetarian café called Arnold's Turtle but he'll never strap on his money belt like a cowboy before a gunfight or storm into the kitchen demanding tahini dressing as if the future of mankind depends on it either.

Another 2 am, I haul a bag of garbage to a mountain of countless others along the curb, sweep up the goop from the ones that rip. Toss water on the ground, padlock the door and walk back to the bank still in my soaking wet apron. The phone's ringing as I climb the steps. I'm sure it's not for me, but lift the receiver from the hook to silence it. A florist I know who has delivered flowers to almost every cafe I've worked is ranting.

"You'll never believe who I'm drinking with—Jean-Michel Basquiat. He wants to meet you." He says. Trying to impress someone by talking about me, it's obvious he's drunk and is still saying stuff that doesn't make

sense when I hang up. But the following night, Motor City taps on the window of the Cauldron after it's closed, and guess who's with her? I don't get it, but in Jean dives like someone finally making it to the front of the line of the reptile house at the zoo. Motor C dissolves into a corner of the dining room. The lights are off because that's what happens once the rest of the staff leaves. The only area that stays lit past then being the kitchen. What a strange little life I have it occurs to me. Even with the dining area being pitch black, I feel over-exposed, am on the defensive. Not that he seems to care, following me back to the pot I was scrubbing just as Motor C stumbles out the door without saying goodbye at which point there's nothing but a dingy bulb swinging from the ceiling, a spring trap in a corner with just enough peanut butter on it to lure the rat that's been prowling and us two.

The rooster comb dreadlocks, clothes splashed in paint. The toe turned in thing. We've been within inches of each other at least twice. I wait for him to say he recognizes me.

"What did Flower Boy tell him?" I ask myself, reluctant to drain the grease from the frying machine as I usually would. Him asking what I do. Me stating the obvious and answering "I'm a dishwasher."

Jean-Michel Basquiat.

Ease down on the "quiat" part and you might forget he's "a bridge and tunnel kid," the bitchy term used to describe those of us without the dramatic arc of having ar-

rived in New York from an America without botanicas and bodegas. If his name were Tyrone Brown or Malik Harris, there's no way he'd provide as much of a thrill to those most fascinated by him. He's hungry he says, wasting no time peeling the tops off storage containers in the frig to see what's in them, shaking whatever he likes into a frying pan he sloshes around on a high unsteady flame when I invite him to help himself. Eating, talking a lot again with his mouth full as I eavesdrop on him with my arms half missing in a dirty water filled sink. He talks a lot about his parents, their divorce, a running conflict at home that makes him not want to go back. He's sure about what he's owed, what's been denied him. He's not somebody you have to keep an eye on. It's like we already know each other. We're avoiding our families for similar reasons. In another life maybe, we were brother and sister. There are the shadows who move in and out of the projects on Avenue D and then there's him to those creating his myth whereas I don't understand why it's taken so long for a black artist so familiar to emerge. His ubiquitous crown symbol, one example. It's got to be based on the Dubble Bubble bubble gum logo. Anyone who spent childhood in one of the five boroughs would say the same. I ask if he's trying to upend Uncle Sam by disseminating ironic protest messages or if his artwork is just a personal marketing campaign. But he'd just as soon strut around in the company of the rich and famous as logo their faces, so his answer's all over the place.

The next night exactly, I see him heading into Tier Three with the standard blonde pixie on his arm. He looks at me. I look at him, both of us speechless. I regret not having been more relaxed about him hanging out with me in the kitchen, but I've got something more serious to worry out. I've just been kicked out for being a couple of months behind in the rent. Maybe it was the way Hank did it. Making me out to be some kind of fraud. I guess he thinks anybody who says they don't have money is lying. Recently, I ran into the man with a soggy rag for a face again who always asks if I want to smoke a joint with him at his place. Whispering at me as if I'm a kitten that will come to him if he speaks to it the right way. I'm starting to think he's a bad omen.

Climbing the steps to Motor City's wearing the green hiking bad that my father bought me to carry things to college, all I consider mine inside it. Either she thinks I'm just stopping by or knows I need a place to crash and doesn't want to make me uncomfortable by asking. There's a mattress wedged into a storage room where you can also sleep, so it's not like I'm stuck on the floor if I don't get the couch that Jean Michel, of all people is competing with me for now. Never thought the day would come when I'd walk into her living room and find him spreading albums across the floor. Playing Sinatra songs that aren't the worse, but I wouldn't listen to if I could get a turn at the stereo. I don't hide that I'm pissed. We get off on our bad chemistry.

"Pay something towards the rent or the phone bill." I say, "Come on. Hey."

"Andy Warhol's gonna give me some money," he claims, showing up without any cash same as ever later. Not that I contribute much myself. Motor C puts up with the two of us with a patience I never knew existed. Just wear clothes in her house is all she basically asks. I give him the silent treatment when he's naked or stomp and shout at him until he runs away laughing and gets dressed. We're both childish, so you'd think we'd be besties, but he's popular, which in my post-adolescent logic makes him the boy least likely to be my friend.

15

At One's on Hudson, middle aged ladies, the type who live in doorman buildings because, and I quote: "They're safer," scan the dark from candle lit booths. Two giving some men by the jukebox a thorough once over when they're leaving the woman's restroom. I've never seen them before or maybe I have and don't remember because there's no shortage of hags here looking to relive their last naughty vacation to Ocho Rios. The odds are good that they'll luck up, even if a lot of the guys they meet will be hustlers. The one flinging his locks and flexing his hips is such a known 'teef,' he should dash out the door with one of their purses and get it over with. Sistahs who make the mistake of coming to One's almost always file right back out sucking their teeth, but it's Tuesday. Richard "Dirty Harry" Hall is deejaying. So it's all about the bass. Not the paradox of Boho black men with neo-classic dicks.

Dirty Harry in a tilted cavalry cap with crossed rifles above the bill. He owns an entire wardrobe of jackets with stand-up collars and double-breasted shirts. Most of his clothes are authentic Civil War gear, but look new and fit like they're custom made. I wish I knew how that works. He played sax with Burning Spear. He, Gregory Isaacs and Jacob Miller were part of the cast of "Rockers," a movie with the messiest plot ever and no "The Harder they Come" by a longshot. I had never heard of it the first time we paused in front of Manic Panic and introduced ourselves to each other. His step was springier then when he was fresh from Yard with dreams of nice-

ing up his bank account in the States but lately he's been looking like he'd go back to Jamaica in a heartbeat if he could just find the exit.

"Why yuh drink 'dat?" he stops to ask tonight, crossing the dance floor during the break he always takes from his turntables. I'm impressed if he says something when he walks by. He's a man of few words.

"All I know about the bottles along the bar," I answer, "Is that if you drink what's in them, you get drunk." Him simply angling the specially contoured glass in his hand towards me that cognac gets served in, even in the grungy former pasta pub that we're in. It glows like a precious metal, has the flavor of a butter rum lifesaver. He gestures for me to keep it.

The first low-fi dub song I ever heard was "Flour Power," a 45 a friend in Antigua mailed me that was basically a dub news bulletin about the contaminated wheat flour that killed 100 or so people in Jamaica in 1976. U.S. media never uttered a word about so many being poisoned or the fear that spread across the island. If not for Naggo Morris, I wouldn't have known that something so grim had happened in a country such a short plane ride away.

Nothing pays more fitting tribute to the Manhattan skyline by night than the urban contemp grooves they play on 'BLS', so I'm not knocking their playlist, but they shouldn't call it "the total black experience in sound," because it just isn't. If I had patience for the satanic frequencies of AM, I'd tune into 'LIB,' but calypso's happy music that sounds out of place here where the sky was

poured from a cement mixer. Luckily, Wackie's is in the shadows of the 241rst Street subway station. Lloyd "Bullwackie" Barnes is the owner's full name. He produces some of the records he sells in a studio in a room behind the cash register. In Jamaica, he's famous. To me, he's this scowling man with a salt and pepper beard who runs a storefront that sniper fires White Plains Road from massive outdoor speakers. He didn't have Althea and Donna's version of "Uptown Top Ranking" which worked out for me because the one by Frederika and Joy recorded on his own label is better, especially the "I'm Still in Love with You," part that plays right before the girls start toasting. Rub a dubbed to it with a *bwoy* with liquid hips at a club in Flatbush and it was pure bliss.

Heavy stuff on my mind lately, so music helps. Aunt D. gone again. "Where is she?" I asked my grandmother the last time I stopped by. I didn't want to hear "She's crazy like a fox" either, but the only way the women in my family can make sense of the battle Aunt D.'s up against is by telling themselves she's lazy. Aunt D in the paisley armchair, wrapping and unwrapping her fabulously long legs that go on forever, waving a Virginia Slim in the air, reliving the complex lives and politics of Natalie Wood, Bogart, John Wayne and other Hollywood legends. Each time she laughs—as her laugh is so lavish for a woman whose been diagnosed as clinically depressed, I'm set free. But you're not supposed to notice the pill vials. She shows up from institutions out on Long Island with all she owns in a few bags. Then, just as suddenly you don't see her. I'm not good at accepting things that don't make

sense. Learn she has a phone number one day and ride the train to a neighborhood on the end of the E line in Queens where I try to clear the mess I find her buried in. Newspapers. Paper cups. Take out trays. More newspapers. TV Guides that go all the way back to the seventies. It would take a team to do what I try to without much success but just letting her know there's nothing she has any reason to hide from me reverses what feels like a curse, for a minute.

About home, if I can still call it that—what I need is a clear line between the day I followed mommy through an aisle in the hardware section of Caldor's to pick out the color I wanted to paint my room and whatever this is that's happening. But she crosses herself each time she coasts by a crucifix outside a Catholic church. Just use the word "divorce" and she goes ballistic.

16

The Sunday Times Classified section weighs five pounds on average. Ads, ads, and more ads I circle. I'll do anything legal about now but wash dishes. It's Monday afternoon. Today I sat on the bed that used to be my parents but is all my mother's now and spoke to a real estate agent that has prospective buyers he wants to bring by later. Siberian weather for days. It's not house hunting season, but okay I said okay and wrote down his rant on a scrap of paper. Now it's ringing again. I answer. It's someone I was barely able to see who whispered into my ear for a few minutes at One's recently. He's called twice since then, the last time from his father's record store in Brooklyn where he's working while he's in the States. Eek-a-Mouse was roaring in the background. It's a miracle I know this much. I could hardly hear.

"Guess who I had a dream about last night?" he pop-quizzes during a pause when I'm getting ready to hang up.

"My favorite girl," he says when I play dumb, and it sounds so ridiculous, but I prefer being lied to with reality being as troubling as it is.

On my way downtown to meet him during a cold spell. I'm the only passenger that boarded the train at 241rst Street, so it's fitting that I'm the only one that steps off at 14th. Climbing the steps, standing outside the station. Gritting my teeth, eyes stinging, almost crying. This could be a practical joke that someone at One's who asked me to dance but I snubbed, got him to play on

me I start to think. Finally, I see a silhouette on the up-town side across the street. It's him. Spirits flee the underworld through manhole covers. He flags down one of the taxis whipping by as if towards another world where the weather's better up ahead. Seventh Avenue's ours. No other pedestrians in sight. The shoulder flaps on his coat, freshly shaven face and tincture of aftershave. He's not another dusty musician or fact-checker passing himself off as easy going by not ironing his clothes. He's solid as a rodeo bull with thighs that could really send a soccer ball gliding. His eyes come alive in the dark of the cab. I can't read them, don't try to. That dimple in his chin. The night he asked me for my number, I hadn't noticed it. It's a good thing Club Negril's open. The bartender runs a cloth around the same spot in resentful circles, timing our every move like they pressured him into working even though there's nobody around except for us to leave tips. Men in slick snake chains and women clutching purses would be shaking their shoulders with a certain decorum on a normal night. But the beat goes on without them. Shifting colors orbit as Lovers Rock fills me in on the most matter-of-fact things. Born in Kingston, raised in England. I picture him small and smiling against the trunk of a tamarind tree, then grown and somewhere gray where people rush towards you with plans firmly set but feelings hurt beyond healing.

If he doesn't call, I don't call because nothing would kill our relationship faster than acknowledging it. I have no idea where Lover's Rock lives or how long he'll be in the U.S. I tell him the same lies about myself I tell every-

one else. There's a wall in the corner of a weekly party in a commercial building on Broadway and Astor we lean against and pass back and forth a Guinness stout. Steering his shoulders like bicycle bars when the bass gets dirty and the horns of Zion ring out. I don't slip and slide anymore when crossing sheets of ice along St. Mark's in my latest pair of throwback stilettos. I have his elbow to latch onto. At a lounge with a neon sign in the shape of a martini glass on Flatbush Avenue, I'm stuffing my face with the food in aluminum trays on a buffet table when "Me come yah fe dance. Me nuh come 'ere fuh nyam." He says, and I just can't get enough of his indignant West Indian man routine. In the hutch under Motor C's stairwell where we usually say goodbye, I hunt the domes and minarets of his physique, he traps my tongue between his teeth, and I just hate how he toys with me when I'm in heat.

I step out of the building where I'm working as a receptionist for a company that, as cryptic as it sounds, manufactures plexiglass containers. It's Spring and raining. I didn't expect it, but he's still in the United States. I think we're in love. It's the first time we've ever been together pre-sunset and aren't dressed to impress. He holds the umbrella as we stroll Park Avenue South. The traffic kind of sounding like seagulls in some spacey English movie from the sixties.

Nothing about the mood he's in signals that something's up the Thursday night we meet at a party held in different warehouses around Canal Street but draws

a twelve tribes crowd that's straight Utica Avenue, except that he orders a glass of Bailey's Irish Cream as if that's his usual when as far as I know, it isn't. He does the usual spirited hand shaking and shoulder grabbing. Steps to the deejay with an armful of records cut on his father's label. I take a spot in a hall instead where the sound is fine, but the crowd's not as thick. Devin, one of the friends who sometimes seem like they're with Lover's Rock for the sole purpose of watching his back, is standing nearby almost at attention because Lover's Rock is the son of one of Jamaica's most legendary reggae producers and some heavy baggage comes with that. Once when we were parked outside Club Negril in a Lincoln Town Car but I'd had enough to drink to feel like I was in a limo, I'd trickled a bottle of Champagne we were passing around into one of my Hepburn shoes. It looked so easy in old movies, but in real life, it leaked through the seams. Lover's Rock still drinking from the leaky heel as Devin reached for it like a kid in an arcade for a joystick, so I'd say he enjoys my company. Boysie and Sean, the other two, play it close to the vest and I have no idea what their story is. But now Lover's Rock's in front of me in the cap and jacket he removed when we walked in less than a half an hour ago.

"I have an early flight in the morning. I need to get to the airport on time okay?" he says with his mouth pressed to my ear with his boys waiting behind him, trying not to watch when he tells me it's his last night in the U. S. the same offhand way he first introduced himself. Days ago, we had sat side by side in dingy seats at Saint Mark's Cinema and watched the movie "Meatballs," his

idea. White middle class coming of age stories will flash across my eyelids as I lay on my death bed they're so unrelenting, so I hadn't paid attention and imagined a movie about a boy next door type I haven't seen yet on the big screen who sweeps an iconoclast like me off her feet.

"You're not allowed to drink alcohol here." Raggedy Ann's big sister says on the elevator after I remove a cold bottle of ginger beer from a bag. Later I would weigh whether I should've offered her some so she could see that it was just soda or simply tugged her towards me and head butt her. But I said nothing, not a word, didn't pay her any more mind than the creep giving himself a hand job near you on the train. I can't fight with every crazy I run into, least of all now that I've got bills to pay. I'm an editorial assistant's assistant at Macmillan Publishing. My cubicle is at the intersection of limbo and the valley of the damned. Every hour here is a year. Countless restless numbers of girls schmooze in front of mirrors in the restroom, dip outside to smoke cigarettes or take unauthorized breaks in the ice blue cool of the food court in Citicorp mall. Girls from Jersey, Long Island, the outer boroughs who really know how to work polyester career ensembles, don't connect the dots between the correspondence they file and recently published books and don't get paid enough to. Sometimes I'm just another one of them, but just sometimes. Not always. I can't prove this but I was hired because I used the word "iconography" during my interview. Not that I was trying to sound more interested than I really was. I saw the job as an opportunity to make sense of why I had taken the

"my body, my blood" rite in the mysterious twilight of the altar back when I still went to church, so seriously. Plus, I thought that being part of a team collecting material for an encyclopedia of religious belief was a chance for me to give the strained relationship with reading and writing I'd had in college another chance. One of the editors offering me the job on the spot. Other girls human resources had sent to his office hadn't cared about the project description, just wanted to get to the part where they showed off their typing speed he had said. As soon as I started, unfortunately, the head editor-in-chief fell sick and until he recovers, everything's on hold, so my desk is empty except for a phone. You could say it's easy money, but not having anything to do gives me too much time to question if I should really even be here as opposed to washing dishes like I'm used to. Concerning *The Origin of Negative Dialectics*—I found it on a file cabinet and decided to keep it. Now I graze it a little every day, all the citations and references. It's not an easy read. But what's not to like about a catalog of Horkheimer, Adorno and Benjamin's biting analyses of the Babylon system?

Gun Hill Road won't ring any bells unless you're from the Bronx. Red Stripe is the local beer, but Budweiser is something imported "from foreign." It's a major strip in a West Indian area that's no Flatbush by a long shot. Still, a number of bakeries sling bun and cheese and beef patties to steady streams of customers whereas McDonald's is more of a kitsch element no one notices. The most famous landmark up here is Woodlawn Cemetery. That's where Granny's buried. Still, the cricket clubs throw get-togethers. Act III has valet parking, live music

and the biggest dance floor you'll find without heading to Manhattan. T-Connection's a spot above a storefront where teenagers into rap go on Friday and Saturday nights even if the rhyming over beats things strikes me as a fad that will be short lived.

My apartment's in the basement of a private house owned by a couple who occupy the rest of the premises. The husband recently complained that I leave my lights on when I'm at work. Because they're always off when I come home, I can only assume that he uses the copy of my key that's supposed to just be for emergencies to let himself in as he pleases.

Rebound Man.

How to describe him? He grunts, doesn't quite speak, has a pronounced Adam's apple. Toothpick between lips. Swabbing his Toyota Corolla with a special cloth he keeps in the glove compartment. The crystal green bottle on the dashboard the source of its endless fresh laundry fragrance. We lack chemistry. He buckles his pants with great concentration, pulling at the strap until the right hole is even with the prong, finessing it through the loop between a precisely angled thumb and index finger, a trance inducing display of manual dexterity that lasts twice as long as whatever we've just done in bed.

It's three months since Lover's Rock left.

I was dumb enough to have gone to college but smart enough to have dropped out after a semester, but that was way back then. It's 1980 now and my favorite bars, clubs, faces are already things of the past. "Rock Lobster's" an oldie but goodie. Time flies between dressed to kill and vomiting on all fours in the snow. Restlessness is contagious. Motor City doesn't want to be limited to a typewriter anymore, has sublet her place, bought a bass and moved to Paris. A few others have left. I'm next.

At Alexa's, Jean Michel's work is almost everywhere. But I've seen it across the walls and doors so many times, I don't really notice it. I tend to only be conscious of where his art isn't like the block where somebody's calling me "a freak" and a beer bottle's smashing at my heels. That she didn't paint over the walls and doors he embellished, howbeit, is attention worthy because he moved on some time ago, and lives tend to layer over lives at a dizzying speed in this city. Alexa likes hosting and introducing people. Her living room and kitchen aren't crowded this evening, but you could say she's having a party, and it's a good mix of folks with less attitude than usual. At some point I meet Hanna who writes music reviews. Recently, she decided to leave New York to live in England with the guitarist in a band riding a wave of success. She's only back in town for a minute, then returning to Birmingham where she now lives. I tell her about Lover's Rock. Everybody knows everybody else up there. It shouldn't be too hard if you want to try and find him, she tells me. If I decide to take the bus north, she says I'm welcome to stay in the house she and her boyfriend share.

17

It's November, for whatever that's worth. I've flown before, but the Laker aircraft I board is so enormous, I can't believe there's any sky left past its wings. Attendants hawking merchandise and snacks, rampaging the aisle. The Freddie Laker logo is on everything. He offers the cheapest flights to England if you don't mind landing in Gatwick, but not even a cup of water's free. Later, when the passenger in the seat beside me is doing a crossword puzzle and an x-ray of myself against the window is my only view, I remember a Chihuahua on the train platform one morning trotting so fast, his tiny legs were a blur. Everyone checking their shoes and watches determined not to acknowledge him. Under the dark axis of the El with him against me minutes later without knowing where I was going. He was slimy, hard to grip. His little paw prints stenciled my shirt. I refused to turn a blind eye to the dilemma he was in. He didn't have on a collar, but was clean so must've recently belonged to somebody, I noted as I walked in and out of blocks of the usual income properties with ugly striped plastic awnings that the people who owned them tended not to live in. At some point, a Dominican super taking him from me to give his wife as a present.

Epistemology's glad to see me. No. He isn't. I wish.

It was only after I told him I was on my way that he realized there was nothing he could do but agree to let me sleep on his settee, so I'm not exactly a welcome guest.

I just got here and already the two hellhounds he lives with are complaining that I should be paying part of the rent. Girls who work in a bar where their job is to entice patrons to buy drinks. Every time I see them, I picture one with some sorry geezer in a headlock that the other force feeds five-star whisky.

King's Cross. What to say about it except that there are lots and lots of hookers wherever I go even by day who tend to be my age and complexion, so each time I'm outside, a whole gauntlet of men wiggle cash at me like I'm this hungry aquatic mammal that will jump out of my tank for it. Even if I'm staring at the ground and hiding in Epistemology's severe wool scarf and coat, them still mistaking me for someone who'd go any friggin where near them.

Hungry but tired of the same old burger and slice of gateau at Wimpy's, I look for someplace else to eat and stumble upon a kebab shop that seems decent. A queue of girls in skirts and high heels who've been working the sidewalk all night enter in front of me. The couple behind the counter watching without rushing to serve any of us. The dining area's empty. It's not like they're busy. Are just overwhelmed by getting so much business all at once, I tell myself, preferring not to read anything into the long wait. The husband's taking the other women's orders with a reluctance when his wife lashes out at him in a language I don't speak, but the tone's easy enough to translate. We don't serve whores here, she's saying. The girls getting up, mocking the wife and the sad helpless expression on her henpecked husband's face and leaving. Me hungry enough to eat something prepared by a

crazy person, however, continuing to read the menu until the wife rushes towards me and commands that I get the hell out too.

A certain red I'm pulled towards, not fire engine. More pale. Moments when I think I've found a clearing. No conflict on my heels, just double decker buses and pedestrians rushing. Aisle, window and center seats. I walk without knowing where I'm going. End up in Peckham. Then, another day Brixton, then Notting Hill. Furry patches of storybook green. Tumbledown shops with signs like preschool finger paintings. End of days bass throbbing a corner shack where I sift and sift through crates of dub records by artists few have heard of with labels almost too faded to even read. Songs by Bunny Wailer, Hugh Mundell and The English Beat following me.

With nightfall comes violence. Boys taking turns kicking a black kid curled up on the ground trying to shield himself with his arms and legs. They have on boots designed for what they're doing, these babies for whom holocausts and ethnic cleansing are sips of warm milk. They're not even teenagers. The kid they're stomping must have thought he was an exception and could sip from the same glass. He's wearing the same trench coat. Same gear. Has the same stencil of shaved hair.

"The police are coming. The police...," voices in the crowd announce as if you can count on the cops to help him and not rush in with nightsticks and join in.

Epistemology shoves junk aside to make more room for us at the table. The window isn't much of one. It would make more sense if we were eating dinner instead of breakfast. Days are dark as night in his flat. Maneuvering his fork and knife so artfully, dissecting his baked beans on toast, coaxing a precise piece of fried egg from his plate. What does such exactitude have to do with this rundown, depressing place? I'd get points for being brutally honest when we were in New York, but I'm no longer as desperate to impress him, so keep this question to myself. Besides, I've only been here for a month but realize that that what I'm doing isn't what I had in mind when I shoved whatever I could into the same green hiking bag as usual in search of someplace better. Combing Canal Street for a dumpling house he'd insist was essential to return to but no longer seemed to exist, that was fun. This isn't. I could most likely make Epistemology laugh again now, but it would only last for a couple of seconds, then he'd go back to just putting up with me at best. I'm aware that he could tell me that he knows all I've got to my name is my last month's pay at Macmillan but will have to leave unless I start contributing to the rent. I'm aware that this news could arrive through tightly clenched teeth, but with an element of apology, the next minute or the next. The film *Babylon* has just come out. Reality fed by make believe. Black yoot versus 10 Downing. Fuck the police.

"Why don't we see it?" I ask. Surprised when he says yeah, then one last time, the Artful Dodger with an Oxbridgey air about him and me, a girl who traded a college with an air of prestige for the University of the Streets take to the street.

18

You wait for the shape in front of you to tug down their luggage, shuffle your way towards the driver.

"Thought we were going on to Bradford," A woman with a Benny Hill sounding voice gripes. In the bus station cafeteria, I spy on a man with a plotting smile who looks like he's onto something no one else is and am trying to get to the bottom of the secret I've always believed the rest of the world is keeping from me as I look around when two dreads storm in, one yanking off his cap to sick the Medusan snakes that tumble out of it onto the diners with blushing red faces making an effort not to look. The man behind the counter refusing to budge. Simply deadpanning them after they order something. The one in a bloated leather hat shifting from foot to foot like a runner before the pistol's fired standing his ground until they're served, and I can already taste the tear gas, hear glass crashing, see boys with masked faces sprinting through dust clouds and flames.

But Hanna's neighborhood is a jittery slide on a toy projector we walk around without heading anywhere special. It's like I'm dead and in heaven. We buy a chicken that still has feathers on it in an unlit grocery one day. The man behind the counter just wrapping it in newspaper instead of giving us a proper bag to put it in. Stubborn patches of black snow I skate across without falling as smarty pants New York punk anthems fade.

I'm here to find Lover's Rock, which I'm supposed to be ashamed to admit because I'm at the age where I should be trying to achieve a worthwhile goal, or so I've overheard, and maybe I would be, if I had parents phoning to complain about the choices I'm making or who even use such cautious language. Yeah. I called my mother when I first arrived in London.

"Oh? You're alive." She said when she answered. Every family has its code. In ours, this would be affection, and when I hung up it was as if for the final time as always.

Hanna's boyfriend, Ed, and his mates in the kitchen in the usual flight jackets and laced up work boots staring at nothing in particular.

"Ta" they say when adding hot water and milk to each other's cups. "Ta, ta, ta..." they exhale like when you ease into a hot bath to soothe an ache. Earlier, Hanna gave me a tour of the downtown area, an eyesore of a shopping district with the zombie calm of a former war zone. Derelict skyscrapers and stores with their names in blinking rusty letters mounted on abiding scaffolding. The Bulls Ring. The Rag Market. My eyes were peeled the whole time, in case Lover's Rock appeared. He regrets having left me in that club without giving me his contact information. I'm sure and convinced that soon we'll run into each other and embrace laughing. Lots of stuff to look at, ramps you circle and sudden tunnels you pass under. Everywhere young couples. Girls already pushing babies in strollers even when you can tell they're still in high school. Young fathers with weaponized heads of hair towing the line alongside them. One with a broad tricer-

atops shield and a single tendril dangling down his face. The girl beside him, in contrast, in such sensible clothes and plain loafers having mastered the humble art of just hoping for the best, all of it reminding me of how disappointed I was when I realized how much I'd have to tone down to be part of Bob Marley's revolution.

Rewind to the kitchen at Hanna and Ed's where Ian's riding a cigarette, eyes lit with surprise by something unbeknownst to anyone but himself. They're on their third round of tea. Linval's a lad whose hung out with Ed and his band his whole life and plans to keep doing so whether they're famous or not. Either he resents my fake English accent or is worried I'm mistaking the conversation we're having with flirting because I feel like I'm being watched rather than looked at. But bonding with the only brother in a room of white friends is usually overkill.

"It's the Noah's Arc myth making you think you're the last two of your species unless you do something about it," is how Epistemology would probably explain our politely forced exchange, but our weird back and forth turns out to be a good idea when he brings up a sound system happening in the area where I think Lover's Rock lives. So, then I'm in a taxi with a driver giving me the usual misguided advice you get on your way to the black part of town.

In London at a club called the Top Rank Suite where I had gone to see Hugh Mundell perform but he was a no show, I'd drunk a Baby Cham and danced alone to a couple of songs a DJ spinned, but I'm the only woman whose hair isn't dreadlocked and tucked into a red, gold

and green hat or scarf. Girls in long denim skirts looking me up and down. I don't really want to stand out any more than I already am. Just look around, browsing faces, hoping one will be his.

"Give thanks and praise. Raise up. Raise up," Nyatafari chats into a grainy mike. Quaker City robo chatting back. Babylon toppling vibrations making the floor shiver. More kids bouncing in bringing the mean December chill in with them. I'm sure that if Lover's Rock were around, I'd have seen him. Am against a wall moaning with end of days bass when I realize I forgot to ask my cab driver for his number so look for a phone with a car service sticker on it. That's when I run into Rich. We met only days ago in the dairy aisle at Tesco's. I was with Hanna. We were doing some light shopping. She had written a review of a band he manages, which he didn't find as positive as he would have liked but didn't mind the publicity, what I read into their slightly touchy word play.

"Stay for the gig. You can ride back with us," Rich says after we recognize each other, so I follow him through a maze of vaguely blinking figures crowding the immense church rec room we're in towards musicians I can hardly see moving their instruments around. Youth in Ecstasy I'll call them to avoid invading the privacy they seem to protect even while on stage, isn't some NY reggae band with flashy arrangements tossing their dreads and pulling out all stops to bring down the house. They're introverts. Their songs sway. Are sad like my favorite Christmas carols. I feel like I know them once they're playing, especially the singer who's beautiful in some way I can't

describe. The two of us continuing the game of peekaboo we began on the floor of the van when we're at Rich and his girlfriend's Lily's flat later.

"Most of the 'yoot demma walk out as soon as the sound system finish. Irie innit?" asks the bass player bitterly smiling with clouds spiraling from his lips, passing the spliff between his thumb and forefinger on to Rich and freeing more hair from his cap than could have possibly been inside it. The mood in the room is sadly contemplative. The crowd wasn't receptive, but Rich must have had a softer, fuzzier gathering in mind when they were carrying their equipment from the van into a storage room behind his kitchen and he suggested everyone stay for tea. He seems stunned and at a loss for words.

"The yoot dem have fe be ready for I and I message, but I man I dunno really," The drummer says shredding more cardboard from a matchbox, spinning it into a filter, gutting another cigarette and applying shavings of black hash to the tobacco before coaxing it all together. You meet the coolest people you're going to as soon as you arrive somewhere before the magic runs out so this is M and I under the Roxanne red light at Motor C's that first night. It's the ghostly neon from the Empire State Building haunting my mattress again. I'll only have the privilege of being someone no one expects anything of for so long, so I just listen to them speak while drinking tea with powdered cream. Powdered cream is growing on me and so's the electric fireplace. I don't think I've ever seen one. They want to bring a level vibe to the yoot. They're not trying to be stars with fans. Cho 'dat. It's life and death. Searched by cops, cuffed and shoved into a

patrol car without knowing why. That's what happened to one of their mates. He hadn't done a damn thing. Thatcher is an unchecked disease. They spit her name from their lips like phlegm, and I'm reminded of the day Hanna and I were followed by a van of boys with rosy cheeks and rat fangs for teeth who called me a "wog" and her a "chink" but didn't run up on us thanks and praise. The way back to Hanna's won't be clear until dawn when I can see where I really am, but everyone else is putting back on their shoes and coats.

"Tyler is guilty the white judge has said so," has stopped drifting from the stereo. The room's quiet when suddenly Maroon and I are alone. Biscuit crumbs, tea mugs, and ashtrays scattering the carpet between us. Even on stage, he was curious about me. It was funny. He broke the fourth wall as I thought, "wow, is he lovely" with him curiously observing me right back. Now, he rests into a throw pillow, crosses his sock feet watching again like a cat ready to be fed at which point he asks how I know Rich. My answer not completely satisfying him. Asking what I did in New York. What I did when I was in London.

"I've never been anywhere but here," he responds as if insinuating I'm much needier than I should be. A city that's a major part of the story of the Industrial Revolution, but where no one's had a job ever since. Why would I come here? I'm looking for Lover's Rock, I explain. I must feel out on a limb he guesses. Not having anything to do with anything is a form of freedom I say, totally straining to make sense. I'm looking for something I won't find, he suggests. Seeing is blinding if there's not

more than one view, I reply, asking if he's ever noticed how lost people in crowds look, him sitting there with his arms folded, leaning against the pillow propped on the wall, listening as if I'm absolutely spellbinding and he can't guess what will come out of my mouth next. You're limited to just watching and applauding once a band comes out, which is why I usually don't take live music to heart but Maroon had seemed as cornered on stage as anyone anxious to get back out into the night air who had left early. I'm with someone who has the gift to fly but doesn't want to abuse it is my gut. Then "what the hell?" I think and stop just eyeing the Gregory Isaacs album under the stereo. Just drop it on the turntable, aware that it's insensitive to be tapping in time with its beat on my leg after such tortured conversation before I let "If I don't. If I don't. If I don't have you, for me there'll be nobody else" transport me somewhere more conducive to daydreaming.

I knew I would escape my past and at that point, ransack the world for the parts with which I would build my own house. The first possessions I'd fill it with being the joy and lightness that until I met Lover's Rock, I had never known, which I tried to explain to Hanna during afternoons when we sat at tables with wobbly chairs at various chaat shops on Ladypoole Road where I'd tug at tough but well-seasoned parts of chicken and she'd graze on gooey balls of pastry with a slightly rancid butter taste. Hanna feeling that I should be playing music because she and Ed had overheard me singing a Dennis Brown tune and thought that maybe I should put

down vocals on a track with his band. She'd heard I had played drums back in New York when Motor C. couldn't keep just staring at overpriced guitars in the window of a pawn shop on Third Avenue and got the Del Byzanteens to let us use the instruments in their rehearsal space to jam, experiment. Hanna having a boyfriend in a group with a hit you hear a lot on the radio—is downright evangelical when it comes to the virtues of playing music and thinks that I'm only searching for Lover's Rock because I lack the inspiration to do something more personally fulfilling, which brings to mind the pub in Handsworth where Ed shot pool with a man with a jheri curl who I only put up with because he said he knew Lover's Rock and had offered to take me to some of the haunts where he was a regular. But once we were in his car, he told us he had to run inside his flat and get something after which we waited with our eyes fixed on the windshield like children in a planetarium until Ed decided something wasn't right, the three of us plunged out, flinging the doors shut behind us and began to run, sucking in the pure amphetamine of wintry air until we were out of breath and every time since then that Hanna had brought up dreams and plans, which she did with a hungry light flooding her expression, I felt like someone with a bad habit she was gently trying to help break, so of course, I feel cornered when she calls out that Motor C's on the phone and wants to talk, because I haven't been in touch with her since she left New York. She'd only know I'm not still in London because maybe word is spreading that I've lost it and need some kind of intervention, I think. Though once we're talking, it's hard to say if that's the case. "Come to Paris. I can book gigs. We

can open for Burning Spear. It's a good situation. The angle being that we're girls. A girl group. Think about it," Motor C. says.

Later, Youth in Ecstasy plays at an event organized by a committee that tried to reflect the full diversity of the student body without realizing that inviting so many kids with clashing beliefs into one room was a dumb idea. There's gonna be a rumble is what I keep hearing. Girls in the clothing design program strutting the stage and getting heckled for being superficial as soon as the event begins.

"I man cyant defend no Jezebel, but don't disrespect da black 'ooman," a natty dread stands and shouts at a white boy in suspenders that rises from his seat across the auditorium to stare him down.

"Saaaaaft. Respeck ya roots. Chuh," someone in the back of the theater lectures the only male model as a beat as thin as a can getting kicked in the early hours on a barren street reverberates, and it's not really clear if the fashion segment is over or if the rest of its participants have second thoughts about leaving the dressing room to face such a volatile audience until the designer, matronly for such a young age, appears and thanks Sunshine Fruit and other local businesses whose names she reads from a card in her hand like people at award shows do. Some applaud when she's done, though not many. A local white pride band plays next, and it's obvious that they're why the girl with a St George's cross tattooed into her scalp where the hair's shaved away, came. Another girl shoving her before she shoves the girl back.

Them tumbling on top of each other and getting up as if they're playing, though not smiling one bit. Pints of lager and food's being sold. Classic Rasta sistren running a fried dumpling concession swamped with customers, handling the pressure better than I ever would. This is during an intermission. If any kitchen where I washed dishes got that out of control, I'd tug off my apron, drop it on the floor and quit, but a rush of business for me was never more money, just extra work. They, on the other hand, are their own bosses. One counting money without skipping a beat. The other lifting a fry basket, tapping loose the grease, tossing powdered sugar on the dumplings in it, with superior time management skills as I count the seconds until one of them breaks and admits she can't take one more second of being at the center of so much enthusiasm. Maroon rushing towards me suddenly out of nowhere. Stubbing his toe, doing some dance that's pure slapstick but saves him from losing his balance entirely. He left the dressing room to come find me he admits, and for the first time since we met, we're face to face again. Nodding in time to each other voices. The government's up to its old tricks, using its usual divide and conquer strategy, he says with his eyes lit by the same current that passed between us the other night. Negative factions in the room spreading hate. It's sick, he says. I'm sensing more melodrama around what's happening than it merits, but there's time still for sirens. A lifeless body on the ground. Someone in handcuffs who's innocent.

19

UB40. The Au Pairs. Rankin Roger. The Raincoats. Musical Youth. Steel Pulse and others jam in local garages and basements in spite of Brum's no man's land appearance. Even if they're famous, they're just other kids you can run into by chance on the road though, so when Youth in Ecstasy takes the stage at the end of the night, they're performing for an audience they recognize, a crowd who hears and sees itself. That said, when Maroon's in front of the microphone with his eyes shut and arms spread, he takes everyone in the auditorium somewhere far away within. Skin 'eds near the stage not sure if they're really under the spell of fuzzy wuzzies they should be chasing back where they "belong" or just stoned.

We pick up where we left off at Keith's only this time at Hanna and Ed's because that night had stayed with him the same as it stayed with me. The odd moment I've been in the throes of something as intense as what I feel towards Maroon always ending up to have more to do with shifting sea tides or planets than something personal, so I don't offer him more information on myself than I already have except that I'm broke and may be going to Paris where I might earn a little something. He's pleased with how the gig went, he says again when he walks towards the door aware that the couch we're sitting on is my bed and that I'm probably tired even if it's clear by how he fumbles with the lock that he doesn't want to get heavy or anything, but he'd prefer if I weren't leaving.

Ed and his band are on their way to a TV station for a live appearance. I save money on a bus ticket by riding in the van with them. The highway's a highway, the same view lacking in the thrill department looping again and again until finally I'm back in the vivid red melancholy of London. *The Origin of Negative Dialectics* still the only book that's part of my luggage even if I just graze a page here and a page there and have never read it per se. In a mournful sort of restaurant with lots of wood and candle lit lanterns, I order eggs, baked beans, potatoes, toast, some ripe plump sausage and a cup of coffee. And wow is it good, even though as soon as I saw the prices on the menu, I should've fled. Next, I'm on a train to Dover in a staring match with my reflection that, as usual my reflection wins. Then, comes the ferry. The only other passengers drunk older English men. It's night. Nothing out there but the heavy breathing sound of the waves giving me the impression that the only place I'm being taken is the abyss and I'm stunned when I reach the Port of Calais, and stunned again later when I arrive at the building in Paris where Motor City's subletting an apartment. I thought Art Deco was a style of architecture unique to the Grand Concourse in the Bronx. But buildings with big chrome numbers and rounded sides, that's all I recognize. The way the French deadpan you as they riff up and down their singsong scales as well as much of what else I experience I find unsettling.

Motor C. dials numbers. People answer. "A bientot," she hums before she hangs up and writes down the information she gets. We're not holed up in some low-rate

hotel where prostitutes bang johns. We are in a polite area off the rue de Rome where I have my own little bedroom that's quiet and neat, which makes me worry how I'm going to survive here with my usual cutting corners and preference for avoiding just about everything.

In a zone on the outskirts of Paris without a metro station, the wind's so windy that waiting for the bus that will take us back to our apartment from the place where we rehearse is a form of abuse. Motor City doesn't take the cold personally. I don't know how she does it. Deep in a derby of cars in a dizzying race through a major arrondissement, the Eiffel Tower appears like something precious falling before it breaks. The zombie ride up a high escalator. Boiled egg garnished with herring, fruit in fresh cream and other random things I've never eaten. My out of sync self-portrait. A series of disjunctive scenes.

Motor C. has people to see. From record company executives to an eccentric old neighbor who lives alone and from time to time needs help. We do the rounds. It's part of the drill, so I have no idea who Matta is the late afternoon that a bird cage suspended from a chord hoists us up to his penthouse in Montparnasse. It's Christmas and we're invited for dinner. Max Ernst. Duchamp, De Kooning and Mondrian as well as other greats of modern art I know courtesy of an oversized book with color plates I checked out of the library but never returned during the spring of my last year in high school. Each time I looked at Dali's scribbled-on Mona

Lisa and Pollock's untidy splats and drips or Max Beckmann and George Grosz's art, I saw the status quo getting a proper ass whipping. Abstraction was even better than watching the Blob chase squeaky clean American teens down Main Street, but surrealism really sent a reality that glorified a few and victimized most sent running. Made me want to draw caricatures with tongue in cheek text around them. I should mention discovering a book of Egon Schiele drawings in the library during my brief time in college. That was basically the extent of my relationship with visual art, and that's my excuse for not knowing that the man who gives me the most simply wrapped sketchbook as a gift after serving us duck in almond sauce is Roberto Matta, the renowned Chilean painter. But I'm too troubled and anti-social for Motor City's Paris, and playing drums with the sort of perseverance that's necessary to be part of a band is way out of my league. Oh, I'd sit at my father's neglected red sparkle Gretsch kit sometimes, but not enough to ever really get the hang of keeping a beat. After coming back from Home with my grandmother, I'd tried to tack down a calypso hit that I'd heard during every walk, every drive we took with relatives. My father seeing how unsuccessful I was at it on one such occasion taking the sticks from my hands and easing down on the swivel seat. Shoulders angled, popping his wrists like someone with impeccable table manners. Later, after months had passed when we hadn't exchanged a word, he suggested we drive to a pawn shop in the Bronx where he bought me a Sangria red conga. It was my birthday.

"Tap your foot," he called out from another room once

when he noticed how uneven the beat I was playing on it was, in spite of his reservations about encouraging a girl to learn what he considered a man's instrument. The Paris wind is cruel and makes my fingers too frostbitten to hold drum sticks. But I'll never stop believing that living out dreams is a form of self-abuse. Motor C is ready for the chance to perform live on stage though.

"If it's all such a bad idea. Forget it." She says when she's run out of patience with my refusal to ever lighten up.

"I spent my last money to come here," I say to which she responds by gathering what's left of the savings she's been living on and tossing it like a flock of birds departing into the air. At which point, I drop down, grabbing French coins and bills as if I'm a contestant on a game show that makes you do ridiculous things to win —because I need it—because I'm leaving, even if I have no idea where I'm going or how I'll get there. Both of us shouting, sobbing. Neither of us wanting to hurt each other. Neither of us giving a shit because we're delicately wired and weird, the fact that we're two young black women just doubling how alienating that is, so even if we're driving each other nuts in the process, this is hardly the end of us being friends. No. It's more like the beginning.

No trains to Calais. The Gare du Nord a mass panic attack. The station cafes have closed. Coffee machines empty. Sub-zero weather. I would bust a cap in the ass of the violinist wringing every drop out of the miserable ode to heartache he's bowing in the distance if I had a

gun. Sitting with my knapsack wedged between my back and a freezing wall, I make small talk with a teenage boy from Bristol deserting the Foreign Legion and a couple of Irish girls tired of being au pairs for bratty French kids.

Birmingham, of course. That's where I end up. Renting a flat in a subdivision where I share a shower and toilet with lonesome slow-moving men with time disfigured faces, but my ideal habitat's never going to be the remodeled loft I give friends tours of, so it's okay. I pay my rent by dusting, mopping and washing dishes in a nursing home run by a family of English Mormons. Just turn the knob. There's no need to knock before I enter the rooms of residents who update me on what exactly happened that led to the moment at which I appear. Sometimes they pause to read my expression and see if they're correct or ask me how I'm holding up in winter weather because they think I'm a humble kaffir sent from the tropics for the sole purpose of caring for them. Then Jane, the blunt plus-sized woman who hired me asks if I know why cans of spaghetti and toilet paper keep going missing from the main cupboard downstairs, and I'm surprised she doesn't realize that when you pay someone so little they steal.

But money, I don't know anything about or I wouldn't wake up so early to sell merchandise and do inventory in a radical bookshop on the high street without getting paid for it. One day I walked in the door and the bells on it chimed and I asked the guy sitting there if he was hiring and the next thing you know, I was volunteering.

Some people are real good at talking other people into doing things they shouldn't. He said it was a collective, that there were others who were also a part of it and if there was any profit after the rent and the light bill was paid, we'd divide it up. Then just like that, he gave me the key to what's basically a small library with a cash register where I'm sitting when the Ethiopian and the Chilean, grad students at the nearby uni, stroll in with book bags strapped like Kalashnikovs across their chests. I'm not pretty enough to be useful to either of them and don't share their belief that you need to become an expert to solve social problems. It could be that they just think I'm funny because they keep coming by.

"Why do all the young people here just play instruments and go dancing?" the Ethiopian asks one late afternoon when we're in a pub near the bookshop.

"And Rastafarianism? It's an ideology the British Colonial Office invented to get blacks to voluntarily leave and return to Africa. It has to be," the Chilean says after a sip from his pint glass, watching to see how I'll react. I have on any old pants and shirt and black lipstick. Neither a brush nor comb has passed through my hair in a long time. I'm a wiseass. We've gone back and forth enough for them to know that. I'm usually reading the critical writing in the books I ring up at the shop though whenever they enter, which doesn't add up. If I say I'm also troubled by the kids they just trashed, it's obvious they'll feel better about liking me. Pressure me to be less ambiguous though and I get bitchy, but "You two dress so neatly to be revolutionaries" I simply tease. I must be a cheap form of entertainment for them that they want

more of because they stand under my window and call out for me to join them for dinner at their friend Ali's a few nights later. Ali's hair is spun from silk. His complexion tea lit. He moves from stove to table with hips that swing like an alley cat's. Another one claiming he's about to transform the world because he's really good at solving math problems. I shove his books aside to make room for my plate. Lamb so hot my whole head is in flames. I cough and out burst tears. Drinking water will make it worse, Ali warns with eyes glued to a crackling newsreel of Muammar Gaddafi on the telly when I ignore his advice and fill my glass at the sink.

"He could be the one to unite Africa," says the Ethiopian jabbing his eyeglasses back up his nose.

Meals can be exhibits, a time to show off your best plates and utensils. The one I eat at his flat a couple of nights later, however, just seems sarcastic. I mean it's not what I was expecting when he offered to prepare me a "typical Addis Ababa dinner." The Italians invaded. I know and they stayed, then something happened that involved Mussolini and ever since then, blacks of the horn of Africa have had a yen for pasta slathered in Ragu is tonight's lesson. The Chilean's not with us. I realize that he's the link that's missing, the Ethiopian and I not making sense together without him. I love his tarnished metal complexion. The way he keeps poking and angling his eyeglasses. I wish I had a pair. I'm wearing my nice shirt. One that's sheer and accentuates my cocktail glass tits but he has an exam in quantum mechanics to cram for so takes my plate as soon as he notices I'm done eating, and I get the hint.

20

What happened after I left Paris was I roamed the vicinity of Victoria Station, sipping this slimy citrus beverage with a chemical aftertaste that had looked so inviting in the shiny picture of it over the machine that dispensed it. Everywhere I went, "Ant music. Ant music...," by Adam Ant mocking me from radios and fizzy PA systems. Boarding a bus to Birmingham next, still wanting to try and find Lover's Rock but determined not to drag dear Hanna and Ed back into it my mess. Asking a cab driver at New Street bus station if he knew a cheap bed and breakfast, which he did, which happened to be in the same area more or less where they lived, which was actually perfect since all I wanted was to sit in the permanent sunrise of Tony's flat and flirt with Maroon again. And I had almost reached the row of shops where Hanna and I would OD on curry and over-analyze everything, when along he came striding towards me on his way towards the high street. He couldn't have been more delighted that I was back in town and I couldn't resist tugging him into my room for a good cuddle. But when the husband and wife who owned the bed and breakfast said I broke the rules by bringing a man in, I pictured the girl from Belfast in the next room with her ear to my wall listening, the snitch. The day she rolled up her sleeve to show me the name of the guy whose baby she came to England to abort tattooed on her wrist, and I told her personal things about me, I thought we had bonded. At any rate, Tony and Lily let me stay with them, being that I was at their flat already almost every day.

Maroon the concrete mystic plucking a flower from the ice in Cannon Hill Park. A bee who actually clings to one of the petals the whole way back to Tony and Lily's that self-immolates with a hiss in the electric fireplace as soon as we walk in. Tony and Lily's was Birmingham's Zen retreat, this space where you could palm a hot tea forever and reflect, but more and more anyone who enters brings reality in with them like Brown, the bassie's cousin. Is it even him sitting there or his ghost? The bakery wouldn't have hired him if he hadn't cut off his dreads he says. Who can survive on the dole?

"Want a nigger for a neighbor, vote liberal or labor," what his parents heard when they first arrived from Jamaica, but never paid any mind to it and persevered.

"Be sensible, not a Rastafarian" they begged.

Mates asking why he betrayed Jah Jah and hadn't stood up for his beliefs. Others able to suss what's he up against, seeing he's under stress. He'll check himself into a psych ward next. The media will call their fight for equality "destruction of private property." Not that I'm saying that the uprising of young black rebels against the police and the riots that will explode throughout this city will involve any one person I spent time with. Only that England is no country to be young and black, and a frustration is building.

"World War I came and gone. World War II just before I was born, and now all I can say is World War III is just a minute away," Mikey Dread narrates this winter on the edge. The snare cracks. Bass quaking same as always. Riding in the van with Youth in Ecstasy to a couple of gigs, one at a near empty pub in Dudley where I pick

up a white pride vibe as soon as I enter but where Maroon simply holds his ground and sings. Crouching at his window watching in relief that he can have his morning muesli as I run laughing towards him with the bottle of milk he talked me into grabbing off the porch of a neighbor he's afraid he's nicked too many from already.

Who is she? A bit posh innit? Doesn't have friends, just money to do fuck all but discover new scenes until the masses catch on, what members of the band probably say about me.

Middle aged guys stalking sex even before the sun sets. I should grab a stone and chuck it at the next one who murmurs, "Psss. Hey."

"Curb crawlers" Samantha calls them, and isn't it great that the curb they crawl is in front of the house on Church Road where I rent flat #7, as my rent book says. She lives next door, so she's had it too. Sometimes she stands right next to their cars, jotting down their license numbers with hookers right there laughing because they know the police won't care. Samantha thinks they're wives may. I don't get how a neutral residential area can suddenly turn so down and dirty once shadows tread the pavement but sunset does bring a raunchy mood. Samantha inviting me in for shots of Pernod, which tastes like a concoction made from boiled leaves that Granny would've forced on me when I'd pretend to be sick to stay home from school.

"We should design a sticker that we slap on the 'bleedin bumpers of the drivers. The stickers would say something that implicates anybody thrusting their you-

know-what's up when they should have some as they're all obviously...," her voice trails.

She's obsessed.

Some nights they're so loud, I just lay in the dark and listen to heels hammer. Cars groan open and slam shut. I'd prefer if lager cans and used condoms weren't on the ground when I look out the window in the morning, but I'd prefer a lot of things like my hand on Lover's Rock's as he holds the umbrella and we share the rain.

Months have passed. I wake to the subtle rhythm of a shower and realize it's Spring. The Chilean isn't just shouting up from below my window to tell me he wants to see how I'm doing. He climbs the steps to my room to tell me that I lack discipline and should move to Japan and acquire it there, then maybe I'll be able to do something meaningful with my life because he thinks that I'm special with a powerful presence that can positively transform society or something of that nature. Being that he's someone who uses the word "corruption" to describe just about everything he's at odds with, I brace myself for the fight fire with fire sentiment I know is coming next as it occurs to me that his balance of idealism and discipline is a metaphor for the masterfully tied scarf but flimsy blazer he wears no matter how cold it is.

21

I sleep on a mattress with nothing under it but a layer of thin filthy carpet because I like being low to the ground. The best way to describe my room would be a failed effort at escapism. I rarely have shillings to put in the electric heater, so I could also say that my room is mean to me. For three months, I've been doing inventory at the bookshop, ringing up the occasional novel someone will enter and buy. I've never been paid, so feel like I deserve the pile of reading material collecting next to my bed. Besides, books are living things. They need to be fed, sung to. The last place they belong is on shelves. Even if I return some of them, I'll hold on to Raymond Williams who's not a name relevant in New York, but *Culture and Society* is my *Les fleurs du mal*. My *Naked Lunch*.

March 1981. Hanna and I are at the Odeon with a guy who does sound for Steel Pulse who says he knows Lover's Rock, and it's like enough already. Not this again. Anyone who's offered to help me find him so far has been lying. But I'm desperate. Every reggae band in Birmingham worth hearing is performing. Some girl dressed like you would for Easter, singing a typically lonesome sounding English melody. The place is packed. You can't exactly make out faces unless a door opens and a little light sneaks in.

"Do you think he'll be able to find us?" I ask Hanna because there was a point when I was willing to spend the rest of my life searching for him, but now it's like

I just want to get it over with. We're in the heart of the crowd when we should be more along the edges where the sound man will be able to find his way back to us from some area he went to behind the stage. Not that Hanna's listening. Soon she's going to visit family in the Middle East and has this plan to trip on LSD when she's with them. I've already told her passing through airports with an illegal substance on you is an awful idea. But it's like she's spellbound by what she's thinking and smiling at it, so my opinion's not registering. A band called Black Symbol's playing. The sound man surfaces again, saying he found Lover's Rock and he'll be on the balcony in a few minutes. The entire balcony being unlit, I'm not eager to climb the stairs. Not that the sound man is untrustworthy or someone who seems shady. Hanna and I actually drank a round of pints at a pub with him earlier. He just has to let Lover's Rock know I'm coming he says as if such formalities make sense in a club where most of the guys aren't wearing deodorant, but I wait one more time for a few minutes, then follow his instructions. The Odeon's a grand back in the day theater that must have been repurposed for gigs. The steps wind higher and higher as I rise like some disoriented virgin who actually wants to be eaten by the minotaur, walking deeper into his labyrinth to find him. Lover's Rock is apparently one of two figures I continue towards. The other a dude in a bubble cap's tugging at a dreadlocked beard.

"Nice, nice." he says to Lover's Rock with the docile smile of someone better than stoned. Lover's Rock not saying anything except, "You still play drums?" I know he recognizes me at least. What I'd like is for him to tell his boy to stop sizing me up with that dumb look of ap-

proval on his face and go away though, so we can talk in private over drinks and he can at least acknowledge the way that he'd left me was savage to say the least, but that's not what happens. Small talk. He gives me some number where he says I can reach him. An operator answering. It's the number of a company where he works that has nothing to do with his father's record label. The dots between him in New York and him here getting harder and harder to connect. But I dial it at least a few times in the next few days, leaving messages. Him never calling back— but I'm persistent until he finally answers and I ask him to stop by and spend some time with me because soon I'm leaving. Him showing up an hour later, checking his watch a lot because he's on his lunch break from work he says before we have the most rushed hopeless sex. Tangled in my blanket alone again afterwards, trying to make sense of how let-down I am, I think of the pen and ink drawings of my favorite childhood book characters that were just outlines against blank space and blame having fallen in love with someone I didn't know on them.

RED

22

One day, I'll go back to the street in the Bronx where I lived as a kid to look at the stained glass I used to spy on the world through, but the front door it was in will have been replaced, so my sacred broken mirror will be gone. But windows will always preoccupy me, though never more so than when I cut the police tape crisscrossing my first apartment. Kitchen walls cracked, perforated. Cupboards missing. A stockpile of putrid food in the frig. The stall you can't bring yourself to use at Port Authority my bathroom. The landlord didn't intend on waiting the 30 years it would take for Harlem to become outdoor café friendly. 'You'll be taking the next guys to court for repairs—not me,' he sighed when I signed the lease.

I scrub. I mop. Kill roaches, all of which I prefer to pacing the long shadow between empty rooms when I'm done. You're a selfish bitch. My mother is wont to say. So I'm not the bloody life-size statue of Jesus in the narthex of Christ the King. Okay. But being called selfish by someone whose demands I've always tried to accommodate even if that meant sacrificing my own happiness hurts, so I stay drunk on guilt and am only truly sober when I'm drinking, which is what I'm doing the first time that Junior, the former occupant knocks or I probably wouldn't have answered. Me simply studying him through the depths of the peephole and waiting for him to go away each time he returns and announces that the gate on my fire escape window belongs to him.

Squatting in a warehouse along the Hudson River without electricity or even a locked entrance, I once dis-

covered a derelict at the window watching as I got undressed so it's never been more clear to me that I need to be more careful.

It's 1982. The golden age of getting robbed—of ninja thieves who can tease a 300 pound door from a hinge without anyone hearing— of burglaries committed in broad daylight by phantoms that neighbors don't hear or see. Just make sure your apartment's not more easy to break into than the ones on either side of it, said the locksmith. That's my plan. But shoving a tangle of tiny socks, patent leather women's belts and costume jewelry into a garbage bag, it plays better on my conscience to acknowledge that Junior and his family got evicted and didn't have enough time to get all their things, so the next time he comes around, I just give the damned gate to him.

I'm 21 now, working at the New York Review of Books in the mailroom, a few rungs up at least from washing dishes at downtown hippie cafes, but still a job I believe is below me. Meeting the demands of assorted dilettantes with wide mood swings, including a female editor whose life calling is to be mean, let's just say it's not ideal. Yet there's a certain prestige in having been selected to patch through urgent phone calls from Jack Henry Abbott, Susan Sontag and Noam Chomsky. That's why I'm shocked when they hire Aries after Russell, whose swivel chair Aries' replacing, decides to take his camp humor and sixties beach party persona back to California to publish a xerox magazine. Aries with his flame of feathery hot combed hair. He's broad shouldered. Only

looks me full in the face when it's absolutely necessary, and at those moments it's clear he's trying with all his might not to laugh. His velvety Johnny Cash resonance not matching the girly way he pivots on his toes when backtracking to do something he forgot—or that hair. My first impression of him is that he's an Uncle Tom set on doing such a good job that he's going to make me look even more obnoxious to the powers that be than I already do. Mailroom people have always been frustrated writers, as far as I know. Aries strikes me as this random guy though, but he turns out to be as bright as hell—in an effortless kind of way. He doesn't give a hoot about reading the New York Review of Books. Only when he's broke and needs fast cash does he flip through the unsolicited copies of newly arrived books piled high in the office we share but just to figure out which ones he can sell to the Strand. The truth is that the Saturday he stops by, I would've greeted the Werewolf of London with the same enthusiasm if he too had owned an electric drill. But later there's an undeniable magic to Aries finessing open a pint of gin like a thief cracking the combination to a safe when the two of us sit on the floor of my living room in the soft light filtering through my newly installed window gate.

I'm not in that frigid room in the West Midlands of England anymore where I mistook a long suicide note for a manuscript. It's April, the time of year we most associate with being happy. Still, only men with easy hips and hands like smoke who blow me kisses as Aries parades me around Christopher Street, can save me from my habitual bouts of self-loathing. Whether we're pro-

voking the doormen at Better Days when we're peaking on mescaline or on a laidback road trip to some "geech-ie" house party his friends decided we should rent a car and drive to in Springfield, Massachusetts, Aries and I are the best buddy movie of all time. I'm thin skinned and combustible and always unsure if my friends are still my friends, but am never able to put Aries on edge, so am elated when he becomes my roommate and fills in some of my three-bedroom apartment's excess space.

His nobody's shit philosophy is beyond the scope of my nervous system, but it's clear he's onto something this night in a shadow of Hell's Kitchen that he stares down a derelict aiming a knife at him until the derelict comes to his senses, folds it back up and strolls away. Convinced that if you threw a pint of his beloved "knotty head" into a tiger's cage at the zoo, Aries would climb right in and get it, inviting the tigers to try and stop him—I had come to believe that he and I were life-size pieces in an easy board game in which every square said "Go" and am not at all prepared for what happens when Country, a guy Aries had a brief fling with, moves in. A prude by com-parison to us, Country meticulously outlines his beard, irons his pants and drapes them from hangers all facing the same way. Whenever he accuses Aries and I of being lazy or says the tacky shower curtain I had bought as a form of comic relief looks cheap it's never more obvious that he should buy the money orders we pay our bills with since he's so devoted to tedium.

He could be an axe murderer for all we know, I tell Ar-ies months later when passing a joint his way. Or unem-ployed and spending the money we give him, replies Ar-ies with the usual slyness after he inhales. We take turns

inventing funny plotlines about Country and laughing, then, in a tone that's sheepish for Aries, he confesses he has no idea where Country works or used to live. I don't know who gets paranoid first, just that the unlit room across the hall becomes a spreading sci-fi like mass that sucks us in. The closet's empty. His shoes are gone too. It's obvious he isn't coming back once we've lifted his mattress and discover a stash of photo ID cards under different aliases, the only evidence he ever existed as for the first time, we're not laughing at Country. He's laughing at us.

Subway cars are the new homes for those too lazy to make better use of Ronald Reagan's smile, but I forget about the misery that's guaranteed if I don't catch up with months of unpaid rent, and am deciding what earrings look best with the vintage military cap with a patent leather visor tilted on my head before I head out to Dave Mancuso's weekly party. Then, Tasia appears behind me in my mirror. Tasia, unlike Aries's other friends, isn't an eye-batting, shrill-voiced Little Richard double from down South. He's svelte with a shoulder shake he does when perturbed by something even if in those moments I can never really tell if he's offended or just playing, but I had gotten used to him marching in swinging bags of designer clothes like a villain with nuclear bomb grade uranium and a scheme. Aries and I making fun of this on occasion. Me preferring to believe Tasia's persona was all harmless pretense. Sales clerks offering to help pick out my clothes as if random opinions have anything to do with what I buy always irritate me. It's no different

when Tasia keeps badgering me on how I should do my makeup and what I should wear.

"Fuck off already," I plead when I can't take it anymore without expecting him to shove me with so much force, I land on my back on the floor with him right on top of me ramming a can of hairspray with all his might between my legs. The fact that I have on pants a good thing because I don't know how far he'd go otherwise at the same time that I'm sure he'll hurt me even more if I fight back and damn is there a lot of strength in those dainty arms of his as Jennifer Holliday shrieks to high hell on a radio in the background like she's the one being attacked by some creep with a hateful kabuki mask face.

23

If I had considered my apartment really mine, I might have revoked its open-door policy but I had been fired as soon as I moved in and begun to depend on Aries to financially carry me through the weeks when I was looking for the next job and the next. And anyway, I also bring in people I barely know like guys who are sure I'm a lesbian and lesbians who are sure I'm really straight for naked encounters that are more fact-finding than sexual but can last for days or even longer if I let them.

Aries sitting on my radiator is always a cue for me to rejoin the living. Tossing whatever shirt and pants at me he thinks I'd wear and laughing at how predictable I am as I get dressed. Peace of mind isn't something you can squeeze from solitude like water from a sponge I'll recall each time we descend the stairs together.

"There's Miss Honeycut," Aries will sing when we're outside again. The more he calls the Afghan in the window of the row house across the street by this make-believe name, the more it really resembles a woman with a curly wave minding everybody's business. And once we break free of the scrutiny of the usual faces puzzled by my second hand clothes and unevenly scissored aubergine dyed hair and we're climbing Sugar Hill, there are a host of other things to comment on like the Adonis at the corner deli who claims he's going to be the first black cowboy in a Camel cigarette ad, but who Aries insists is lying or the pig parts in bodega refrigerators that look like Joseph Beuys art you can actually eat.

Aries moving against the flow of crowds with an air of transcendence, amused by the dog eat dog hymns of traffic. His shoulder will be my pillow in the wee hours when we're wasted in the cars of empty uptown trains. Most of the few sublime moments I'll ever experience, I'll spend with him before the two of us get evicted, but so much will happen first.

Mary Lou Williams once lived in this building. The hallways rang with her piano back in the forties. The super told me. Dizz. Charlie Parker. The heaviest bebop cats rolled in and out of her place to jam on drums, stringed and brass instruments. I have no idea which apartment was hers exactly, but if it were the one where I now live, that would explain why Aries and I just can't stop partying.

But I have to mention Eugene because if not for him, I would've just ended up living in a basement in the boonies of Borough X again. Climbing 145th towards Convent Avenue a few days ago, avoiding the soop soop sound behind me, low and behold, I turned around and there he was looking as fresh as ever in high cuffed trousers that showed off his nicely contoured ankles and buttery leather loafers. You must like it when guys make noises at you, he said smiling. You must like getting mace sprayed in your face, I answered. Is that what you were getting ready to do? He asked. Well, why do you think my hand's in my pocket? I quizzed him. You don't have anything in there, he answered, slinging his arm around my waist. He was pickled in designer fragrance. The usual question mark of meticulously moussed hair

tumbling between his bright snapping eyes. I should call you jive Eugene, I said, removing myself from bronze James Dean's affectionate embrace.

We met at Bentley's, a midtown club with not just the name but polish and scale of a luxury car showroom. Justine's, Pegasus, Leviticus—they used to draw the afterwork set. But now Bentley's is all those spots combined into one and then some, so if you're twenty-something and in the mood to shimmy your shoulders with an air of sophistication in spite of how trifling your salary is, there's no better place to go on Friday after you leave your desk. Niles Rodger's prim and proper guitar licks and Jody Watley's girl next door vocals are actual anthems here. I have never seen a single woman inhaling powder from a folded twenty or even passing back and forth a doobie in the restroom, and when "Always and Forever" plays before closing time, fellas search for partners to sway in time to it with cheek to cheek because the old school customs of our parents are still an influence even with hip hop's bitch and hoe politik nipping at our heels. Green lipstick and knife toed stilettos are my M.O. I mix up stripes and plaids. Worn and faded with brand new, so was on the high road to nowhere the same as I am in Lower East Side hang-outs where the only black records you hear are imports or Motown oldies and the pigeon toed, palsied hand routine passes for a mating signal. Men I'm attracted to are not stressed out. Aren't know-it-alls. Have a smoothness about them, are neatly attired or even better. They should also at some point ask what I'm drinking. Eugene was too broke to afford the trip to the bar part. But the thrift shop Fedora and fifties tweed coat were eye catching. I could tell by his Morris

Day mannerisms that Boho was just one of many tricks up his sleeve. He liked my sense of humor. We looked good together. A woman told us that once when we were strutting side by side along Park Avenue. He slept on a broken cot in his grandmother's living room. Keeping his on again, off again girlfriend around because she foot the bill for shopping sprees at Bloomies. His older sister lived in a homeless shelter. The mom that had given them up, lived on Ward Island in the psych unit. You couldn't talk to him about much. He only really came alive when catching a glimpse of himself in a window pane or was artfully gelling his hair in his bathroom mirror. Burnt greasy fried bologna and eggs he washed down with kool-aid like it was manna from Heaven, the damage done back when he was a foster child living with a string of random crazies who had taken him in for money—that's when it most showed since there was no way in your right mind you could consider such dreck a decent meal. I see a guy I like and create a feel-good story around him. From that moment on, my imagination goes racing because all it wants is one chance to get past reality's disappointing limits. Fantasizing about someone should be like giving them a gift unless you're malicious, so I turned Eugene into someone I thought he deserved to be. I knew he was a messenger in the garment district but he became someone who worked in the fashion industry in my head—not that I was up to having a career conscious boyfriend. Actually, I would've put up with him longer if he hadn't stood me up the last couple of times we were supposed to hang out together.

"Beer tastes good on you," was a good line. I'll give

him points for it as well as his suggestion that we have breakfast in his neighborhood early one morning after clubbing because "Wow," was what I said that first time that we surfaced from the subway into the birth cries of morning on 145th and St. Nick.

24

Old timers talking lucky numbers, I sometimes smile at them. "Gone with the Wind" is droning on a snowy black and white TV again when I hear what I think is Butterfly McQueen's voice, then and lo and behold there she is next to a brownstone on 144th as hallucinatory as it seems. But only in Harlem is the silver haired lady getting a little afternoon exercise a Hollywood legend. A man gliding by with more pizazz than your average old timer, during another walk I take, has got to be one of the Nicholas Brothers, I figure. Not that I've sat in front of a TV since I left home, but everybody knows Clarice Taylor's the grandmother from the Cosby Show. There's something cool about sighting her but if her eyes harden and jawline tightens, I realize I'm gawking and it's rude. Then I'm edging along the block once, the tables turn and she's inside a parked car gawking at the math equations I've written all over my face in black eye pencil. Burt Wallace, the piano player in *Robeson,* the Broadway show about Paul Robeson that Aunt M. and I saw together—he lives around here too. I don't know how my mother met him, but his name has always come up whenever she reminisces about fifties night spots where she rubbed shoulders with people like Bunny, a lady who introduced herself as an aspiring actress.

"You've got a great look. Do you go out?" she asked to which my mom cluelessly replied "Yes." The two of them exchanging numbers with a vague plan to hit the town together. Bunny later calling to basically hire mommy

to sleep with a couple of well-known actors, because mommy hadn't fully understood what, "do you go out sometimes?" actually meant. But Burt was the Svengali that brought out the stifled starlet in Mommy even after she married Daddy who didn't mind her having a male hangout buddy since he was gay. Burt, who adored her Bardot eye makeup and windswept bangs, was performing "Moon River" at a supper club she once told me when he decided to lift her on top of his piano and hand her his microphone on a whim, and man did she love the applause she got for being a moody force of nature that keeps everything around her in flux as she sang-talked her 'way through a verse of it with the bitterly velvet candor of her idol Carmen McRrae.

I was inspired to make my place as comfy as Lisette's, at first. Lisette born in Cap-Haitien. Raised in New York with a goofy way of pronouncing R's like W's who I met in an elevator on our way to the same company to interview for some BS receptionist job neither one of us took seriously. Weekends at her and her roommate's place out in Fort Greene where a Paradise Garage membership card and a brownstone apartment are the black female starter kit, were grounding, but Jean-Jacques Beneix's film *Diva*, which I saw so many times the trance it put me in will never end, reminded me that decorating can't hold a candle to sitting alone in the shroud of blue or amber bulbs in the torch shaped fixture on my bedroom wall.

I begin spending an unreasonable amount of my severance pay on junk a couple of months after I've moved

in. This is after I've already lost my job in the mailroom. I try to spend as little money as possible, but if Lisette and her roommate can't stop buying vintage iron skillets and earthy ethnic wall hangings, bright plastic tchotchkes in the bins at El Mundo on Broadway and 145th are my fetish. As long as I can remember, I've confused junk for magic talismans, am on my way back there again when suddenly a sick dog's at my feet. I'll never understand where he came from since he's too weak to have to have reached where he is alone. I can see the outline of his ribs. He's small with a pointy nose and high elongated ears. His brown and white fur caked with tar or sewage backup maybe. If only I could cry out for help and someone would come running and take him to the place where he can get the care he needs, I lament when I'm rushing back to my apartment to get him water and something to eat. He strains to lift his head, to open his mouth for the ham I try and feed him and water I drizzle on his tongue. He's a scrapper alright that I can tell didn't end up close to dead on the ground without a fight.

It wasn't just the sight of him heaving, it was the persistence with which he fought to breathe that pulls me back to him early the next morning when a woman hauling planks of wood with rusted nails out of the townhouse she appears to be renovating pauses to scrutinize me. She's definitely not from around the way. Looks more like someone who would own a home in Canarsie or Howard Beach whose doubts that you can turn an inner city fixer up into a sound investment are stoked each time she sees me on my knees on the sidewalk, helping a dog she'd prefer to sweep up and add to the debris in

the dumpster in front of her. But the Christian Avenger appears out of thin air. I became conscious of the un-eaten cold cuts, plastic water bowl, and piece of a card-board box I'd folded over him to block out the sun when I note how fast her eyes are flaming. I know she'd been waiting for the moment to catch me in the act of doing something she considers illegal, and finally has me. I'd seen her before in an array of kooky hats that British aristocrats and black women are known to wear on Sun-days. Now that she's not greeting congregants before the service, she's not as personable, unfortunately. Jabbing her finger at the sick dog between us, "You cannot do this here," she emphatically repeats. As hard as it is to stomach the irony that someone from a church is stop-ping me from being charitable, I know I'd be wasting my time if I argued with her, so a dying dog becomes a guest in one of my empty rooms, an inconvenience I accept because the load I would've carried otherwise would have been heavier. Bathing him with a warm sponge, I expect to soon be carrying his corpse to the park where I've already decided I'll bury him, but the grimy string that trailed from the end of his spine blooms into a high fluffy tail. The tar caked fur that I had clipped away soon grows back in evenly. Spinning around and around my legs all the time practically smiling or licking my face as if he had prayed that someone save him and his cute little dog prayer was heard.

"Is that the same dog Miss?" kids call out when I walk him. Others gape in disbelief. The key is to zone out, just float. Let them pull and follow. Not be Miss Goody Two Shoes who helped the dog that everybody else left for

dead. Kids calling out in singsong voices I largely ignore. If I were to get to know them—I mean the block's so narrow, and unless I've been smoking and I'm paranoid, I don't pay attention. The problem is I already have Spunky. A dog with a Shepherd's mask, shiny hair and the short snout of a Labrador that had been mine since the day in sixth grade when my mother walked in and gently set him in my arms without even asking. He was a puppy that had been run over by a cab that cracked his tiny hip. Wherever I went, he went. Hopping at first until he healed. There were times when I'd take him with me and others when I'd leave him with her since I'd been tagged to be his caretaker when I was too young to understand how restrictive my life would be. But as soon as she'd whine that he was my responsibility, I'd feel like a deadbeat, even taking him to the unlocked warehouse where I squatted and Epistemology stopped by before he left for England. He, Spunky and I that day crossing West Street to sit along the high ledge above the waves. Spunky vaulting in before realizing that he was in a river, not the simple brook where he'd cooled off on hot days up in Westchester. Trying to keep paddling, his head sinking as he lost strength. Watching my childhood dog drown in the Hudson, I would surely have od'ed on pain killers later. Epistemology scaling down the wall somehow and shouting Spunky towards him. A good Samaritan tugging them both up by a cable. The startling visits to the end and back again you take with pets. I sleep with bent legs to make room for one more now on my mattress.

Harlem's one big attic that extends even further than the *jumbie* possessed crawl space in our former house where we stored things we'd outgrown but couldn't bring ourselves to part with. Lanes as posh as photos of London you see in Tatler downshift into blocks of tapped out tenements where apartments have holes cut into their doors that you can shove five dollars into for a nickel bag of weed. Young white males fresh off the George Washington Bridge from Jersey poking their heads out cars to ask where they can cop. Now that gets to me, especially when I see some naively hospitable neighborhood kid encouraging them to keep coming by giving them directions as if you could roll through the streets where they live and expect the people you pass to help you buy drugs.

"Ask your mama. She knows," I say, not caring if I just found out what a dream book is or that most of my neighbors think I'm sick in the head.

Harlem's my new home and homes defend their secrets, though there's one secret everyone who lives near St. Nicholas Park does a damned good job of keeping or maybe they really don't know about it. Usually I let Kipper and Spunky off their leashes as soon as we enter the gate at the Saint Nicholas Terrace entrance, an almost always deserted block of yesterday's facades frozen in time that becomes a black hole as soon as the sun sets. Down by the basketball court, you see other people. The park though, is not the most popular destination and is always basically empty. I get lost in my thoughts when the dogs roam the hill behind me, turning to call for them when I'm ready to leave one night, I don't see them and

can't figure out where they've gone. Shuffling into a trail of thick vines I'm braced for a living composite sketch to leap out and grab me when a man whose face I can't make out surfaces. Damn, I think. No one would even hear if I screamed, but he ignores me, leading another man by the hand into brambles so dense at points I'm worried I won't be able to find my way back out again as another, shirtless with his chest rounded appears, crosses my path as if under a trance, also blending into the murmuring leaves. It's usually something I just stumble across when the weather's nice, though it's nippy outside and I haven't freed the dogs of their chains yet when I see a young nerd and a chunky older man in the throes of something heavy against some rocks another night near the entrance. If they had just taken a few steps, they would've been in the bushes and had more privacy. I would've never imagined the younger one in an unlit park having sex. He strikes me as a geek who'd spend all of his time mastering chess strategies. The older man though, I've seen him a few times eating grits and eggs at the counter at Miss Pearl's with a woman that's most likely his wife.

25

Athletes with muscular asses, hands on hips, sweaty and switching across a field. That's how the guys in the park strike me once I'm used to them and pay as little attention to their nocturnal sex rites as the sports event humming on a bar TV. Guys, gay or straight are puzzles I can't solve and it would be the worst form of masochism to want to. I'm just ending another relationship. Threw out the mattress we slept on together to wipe the slate clean. Vaguely cute random men I use for recreation like a seesaw or swing, then later make fun of with Aries, that's easy. But opening up and telling one things I otherwise keep to myself as they listen and tell me secrets in return, I can't get enough of, which is such a "don't" for we girls who laugh at the words "wife" and "husband" and don't expect more from the men we sleep with but for them to pass the joint and chip in what they can towards our abortions. Clinics around Gramercy Park run box ads in the classified section of almost every newspaper. Waiting rooms crammed. Freaky Right to Lifers waving photos of bloody foetuses at you before you walk in. Abortion has become a form of birth control for some of us even if we don't realize it. Nobody uses condoms. The pill will make you depressed or give you acne what I keep hearing and diaphragms are useless when you wake up too horny to even think about reaching for some rigid rubber device that takes patience to put in.

Beefsteak Charlie's on Times Square is where Motor C. and Fiodhna are waiting on tables lately and where we all recently drunkenly chanted the chorus to "You Dropped a Bomb on Me" by the Gap band in response to a nuclear war with Russia that's supposedly about to pop off because we live in a country where war drums never stop beating and the apocalypse is just another day of the week. Tylenol caps nicked off by unknown fingers that poison the pills inside and place the bottles back on store shelves as well as what happened to Aries' friend, Don—well, that's something else. I didn't really know him but found him likeable enough to be troubled by news he died from a new mysterious venereal disease. Aries and I had stopped by his posh penthouse on King Street to drink with him and the crew of Rican B-Boys always installed on his couch, one of whom was his lover but is now denying it. But that's just gossip. The moment you hesitate to put a straw into a container of orange juice because you're afraid it might be spiked with a toxic substance or think that making love can kill you, the shadow, a kind of correction that reinforces conservatism, division and distrust before it retreats like a blood bloated mosquito to wherever it came from, has caught up again. It appears at least once per generation, yet I'm outrunning it when after almost a year of sleeping on the floor between my two dogs mourning the loss of the next to last sadist I will ever let toy with my feelings, my moody flight through the street continues with new vigor.

Aries laughing at how full of shit men are, me suggesting he get a girlfriend, him telling me I should do the same. Believe it or not, that drunken conversation was the catalyst. That and the acute pinch of the autumn season as well as the fact that I'm androgynous and have only scraped the surface of what that means. The bar looks small from outside but its corridors zigzag. A puzzle of lounge areas. Chicks stalking balls on a pool table. Women body to body, eyes closed, glowing. Are you a butch or a femme? one asked the first time I came here. Dinge queen. Snow queen. Tranny. Fish. Fag hag is what a drunk at the bar at Peter Rabbit once called me. Gay men slang is all I speak. I can't imagine women being half as technical or distilling who I am into a couple of words. Of course, Yoruba might say I like keeping my distance because I'm a middle kid. Yoruba the master mind reader with bottle blonde dreads she adorns with girly cowrie shells and other earthly accessories.

"Hi Leo," she growled sizing me up the first time.

I asked how she could tell.

"You remind me of my ex," she answered. The music louder than whatever she shared in the next few minutes. Not that she seemed to care. She stops by for an after work drink and splits before they start stamping hands, collecting money and the mayhem begins.

"Well, I've looked around and you're the only one in here I want to talk to," a middle aged swinger in a cowgirl hat waxes poetic. She and her two rodeo girlfriends who have been on the prowl all night for someone who wants to have a little fun with them back at their hotel room, trying their luck now with me I guess, and I can't decide whose more obnoxious, the guy with the melted plastic

mask for a face right there whispering at me no matter where I am in the first shy hours of morning, or them. Regulars bitching that straight women are infiltrating only get on my nerves as long as they're not outing me. A lesbian photographer I met when I still washed dishes once took me on a tour of her favorite bars. New York City became a folksy Cape Cod beach town that night. But I survived it. It's rare that I find being in a group of other women inspiring, but the dark has become a psychedelic church revival and "Let No Man Put Asunder" is so soul stirring, I wish I had a tambourine to bang on my leg when Cassette takes my hand and pulls me into the heart of the thanks and praise euphoria and overly ripe smelling pheromones of women enjoying themselves. The black zippered catsuit. Hips drifting. Eyes offering me space to run in. I'd admired her outfit earlier. She has this mystique. I can see her kneeing James Bond in the nuts, stroking his face and humming "The Girl from Ipanema," in his ear next. She watches me back like she knows I'm impressed by her moves and doesn't blame me. Half-smiling. Glassy-eyed. She's high on something. I'm not sick drunk but do feel woozy. She has me by the hand again. I don't know if she's playing a male kind of role or mommying me. Either way I'm in. Ordering me a seltzer, feeding me the glass. Her lover watching us from a corner scowling. Cassette. Wow. Cassette.

The next morning, I grab the phone on the first ring, hoping it's her. It is. She wants to take me to a theater where *First Blood* is still playing. Her treat. Rambo is ridiculous I moan. "Oh? I've never heard anyone say that," is her reply. I'm too groggy to want to win an argu-

ment. We meet on the corner of Time Square. She buys the tickets. I'm hungover, forgot to put a bra on I vent in an old school restroom with back in the day faucets and mirrors in garish frames. Lifting my shirt, her mouth tilts halfway again as she admires my tits. I'd say I was going to get popcorn, then make a beeline for the exit if a guy I barely knew were to hold my hand as firmly as she does once we're seated. Counting the minutes until the credits are rolling. I'm hyper. Can't sit still.

She and the girl she was at the club the other night with got pregnant at the same time during high school, deciding to move in together after they graduated. I can't go home with her. She can't come home with me at the moment as much as she'd like to she sort of explains. Daylight triangulates as we head down the steps to catch our trains. She's riding out to Cortelyou. I'm going up to One Four Five. Transit cops get their rocks off watching us goodbye kiss.

Our relationship is exhibitionistic. We're really only lovers in public who offer hope to lonesome looking girls watching us mop the sweat from each other's faces in the ladies' room at Bentley's. The gauntlet of fab young men at a party growling, "Git it ladies" one night that she tugs me around behind her like a show dog on a chain. A serious short's in the wire, however, when we're alone together. The first time she steps inside my bedroom, sees the dogs, my books, spiral notepads scribbled with lyrics and clutter I always seem to have so much more of than anyone else, I can see her cracking up until her eyes are tearing, trying to describe me to her status conscious Brooklyn friends. The typical Fashion Institute of

Technology dropouts with exquisite taste in drugs, decor and apparel. Devout members of the cult of Larry Levan who live in blue-collar complexes around Linden Boulevard that they max out credit cards to furnish and rent by the skin of their teeth. The good news is that I have a mattress again. Cassette and I are not rivals pecking each other's eyes out over some petty lying man destroying us. We're nursing each other, nesting in each other's body heat. Then, "Look at your nails," she says looking exasperated. It occurs to me I'm supposed to cut them, but wouldn't know what she'd expect if I did. I've never wished I were being fingered. So can't imagine anyone else would want such a thing. My idea of sex is hopelessly hetero. The learning curve versus instant pleasure. Is it possible to be just a quarter or third lesbian? Bisexual is an okay description for a chrysanthemum beetle, but not me. One day, a god with a bronze bell for a head named Ronaldo will describe me as "split," in one of those rare moments in which someone I know will look me in the eye and share their most candid impression. If Cassette had it her way, I think she'd organize our erotic tension into a task like folding laundry since she's always in a hurry. I bounce into her and her girlfriend's apartment days later and briefly see what it's like to be a mother way before you're supposed to. The disputes with her kid's dad. A massive house divided into units that different relatives rent who are all kind of judging her for something she was supposed to do but didn't. Washing down beef patties with Irish moss drinks as she walks me to the subway station. Embracing each other to the usual sound of men catcalling us. Preferring to believe

God's got something better in mind for me and not accepting the mean serrated boxcutter she takes out of her pocket and offers in case I should need it, before we go our separate ways.

26

I'm in a band. The Guerilla Girls Hand to Hand Combat Young Ladies' Cultural Exchange Program was our original name. Alexa came up with it, but we shortened it to The Guerilla Girls, of course, wanting something easier to say. Jamming in a cellar that belonged to another band at first, The Honeymoon Killers I believe. I wasn't paying as much attention then. Would just pound drums and guzzle cheap brandy from a pint I kept on the floor next to my hi-hat pedal before I couldn't stand the labor of drumming and began to just sing and write lyrics. Fiodhna's on cello. She can keep a melody and bow with feeling. She's from Dublin and so's Vanessa even if she looks like a translucent blue Hare Krishna deity. She uses a mute on her trumpet. It helps mask the fact that she's just learning how to play. Miss A doubles down on one bass lick. Won't let go of it. Like Jah Wobble, she's a dub disciple. Dub is what unites us. It's our religion.

Death to the cock rock poses of Van Halen and Prince.

We're firmly united in refusing to deal with either a guy or girl guitarist, actually. Fiodhna and Alexa recently knocked down the wall between their apartments in the walkup where they live on East 12th Street between A and B. so it's one big space now where we spread out and compose music whenever we want. We're getting deeper into whatever it is that we're up to. I've never been a natural at writing poetry or fiction, but words written to music come easily. I really like the verse chorus verse

thing. How one minute you're an individual, but then it's like you're part of a crowd chanting, "Back door. Back door," and slamming the sides of the bus until the driver submits and lets the rider in the rear off. I mean that's how I feel when I sing a chorus. I respond to a good hook. Jody Watley's pouty vocal tics. Bacharach's felt refrains. How Ari Up can make a torch song snotty or Astrud Gilberto always sounds unaware that anyone's listening.

I'm still hiding behind an invented identity that I'm getting tired of. Talking with an accent, behaving as if I'm a foreigner—so soon I'll stop, but then I won't make as much sense, so will flee the U.S. in search of the freedom of being a stranger again. Trying to learn how to be myself, mostly under social pressure when I'd really rather not narrow myself down to accommodate anyone else's demands. I can think of at least two guys who dress like aliens and claim they're from Outer Space that no one ever questions. There are people down here who were destined to do what they're doing. The ones whose names are in block letters on Xeroxes pasted everywhere or stenciled into the asphalt in the street. Then, there's me.

Paranoid during rush hour.

Why did I decide to smoke a joint as I was getting dressed? I march through the tunnel to 42nd and Fifth the same as everyone else that just got off the downtown D even if it feels like I have three or four more legs. I'm getting worried that no matter how much I keep walking, I'm not going to reach the staffing company where

I meet and greet job applicants and test their typing speed because I'm still equidistant from where I started and my destination. The tunnel keeps bending and extending until a guy with a sweet smile says, "Whoa now. You okay?" offering me his arm and leading me towards the turnstile, which really really helps. I've seen him in the West Fourth Street basketball court in the flux of bruthas dodging and driving towards the net as if on some lifesaving mission or at least I think that was him, but he has on a tie now and my best guess is he's a bank teller because he has a customer service-oriented way about him.

"Here," he says when we're outside. Grabbing an orange from a cart, paying the man selling them, peeling it and explaining the citrus will cut the high. I'm so glad we met, not that I'm any less stoned when I reach my office after which the husband and wife couple I work for and I exchange intense vibes the whole day. But it doesn't matter how freaked out they are about my pushing "the office attire envelope" and my unprofessional behavior. I'm fed up with being a receptionist and quit, applying for a messenger job at Archer Courier days later. Messengers dress any way they want and delivering things is so easy, you don't have to pay attention. Don't quit your day job they say, but I'm not listening.

Sun dried horse shit. Dumpster roasted waste. Midtown in heat. Trains tagged with graffiti that rolls by like movie credits. Windows so spray painted, you can't see what station you're pulling into. You ride the same subway lines with the same other messengers delivering

letters and boxes to the same places. Secretaries and receptionists in polyester suits hoggin up the sidewalk are nine-tenths of the workforce. Vendors hawking gawdy bracelets, belts that go with career shoes. Hot dogs and pretzels. Monotony. Stress. Sit down and wait they say sometimes when I get back to the base near Battery Park, so I take a seat until the dispatchers give me more manila folders without any idea of what's in them and drift back out into the thick of faceless pedestrians and fleets of yellow taxis. Am in the elevator of a kryptonite green skyscraper within walking distance. Some dingy upper West Side office after that—rushing to pick-up a package a couple of blocks away afterwards, only it's pouring and I don't have an umbrella.

Bike couriers, now they run things. They own the street. Lined up at the light in shiny tights like racers waiting for the gun to fire before state-of-the-art pedaling full speed ahead. Pushing cabs and buses out of their way. Leaning to one side. Crouching. Dismounting. Lifting the bags from their chests like dance partners they're spinning. To think that something as trifling as the fax machine will make such a quixotic culture extinct.

It's the summer of '82. The summer I stop combing my hair and let it dread. Bleach it. Rock rhinestone chandelier earrings and rakishly slanted vintage military caps. Honestly, I enjoy being me more than ever. Friends of friends roam into Guerilla Girls rehearsals to observe us because what we're doing is interesting. We played at The Busker's Club. A pit in the ground in which I had to be wasted to handle the audience circling,

I must admit. Giving a mob a license to gape at me was a stretch, but soon I'll have enough to pay my bills I tell myself because our records are going to sell.

The dispatchers give me carfare, but I'm making close to nothing so am on a financial dead end just like when I washed dishes only at least then, I was able to steal wine from the walk-in frig and eat for free, but I dress any way I like and am not confined to a desk. At the base sometimes I check out who's who. The messengers are all men except for a lady who just had a baby and says she's only delivering packages to lose weight and a girl from Long Island with a mullet who never smiles but leans over suddenly one pay day and asks if I know where she can cop some "angel dust." We're independent contractors, not even co-workers. None of us will stick around for more than a few checks, so there's no point in even acknowledging each other, never mind schmoozing. But there's usually someone who can't resist like this man older than the rest of us who suddenly confesses he walked into a company in the garment district to pick up a package on an empty desk in the reception area recently, saw two fur coats hanging in an open closet and decided to grab them, hurrying outside with one over each arm and roaming past other low paid delivery guys with clothes on wire hangers slung over their shoulders or on racks they wheeled through the street, knowing he didn't stand out in an area full of fashion industry activity. He wasn't worried about getting caught as much as blowing a once in a lifetime opportunity to make some big bucks in a fast few minutes. The coats on his arms looked plush. Figures danced in his head. He sold them

he said but it must not have made much of a difference as down and out as he looks leaned to the side telling us this with his hand over his mouth so the supervisor can't hear.

Uptown, then downtown, then back up again. East then west, then west again. Packed insufferably humid trains. Working for a hip graphic design shop in Soho that pays a bit more next. Knocking down icons. Spitting at success. Romancing mistakes, accidents, dead end experiments. I survive the mean winter months until one sublime early summer day I'm on West Fourth Street in the heart of the drum beat of basketball players and break dancers in blingy gold medallion necklaces 'tryna to get paid. One spins on his head and I'm amused by the state of shock the crowd forming around him is in when I run into Stephan, an ex-boyfriend's running buddy and ask what he's been doing.

"I'm seeing a light skinned sister from New Orleans with green eyes and long hair," he tells me and I'm hoping he's joking but realize he's serious before moving on politely because I'm anxious to get to Washington Square. It's Friday. "Freaks" from Jersey City, Newark and the surrounding boroughs hold down the center lane of the side facing Sixth Avenue. "Freaks" being what uptown homeboys hauling heavy beat boxes say to each other about us when they roll through. Fierce catcalls and music instantly resuscitates me. It's the summer that restless gay or gay curious kids of color have co-opted the streets between Greenwich Village and the Christopher Street pier. The other "Summer of Love" I call it, comparing what's happening to a West Coast

hippie phenomenon because anyone sitting shoulder to shoulder on this runway is considered bugged out in the neighborhood they come from. Plus, we all like to trip on mesc. Yo. Zootie Bang, what's up? A female construction worker says to me from her throne on the backrest of a bench. She always cracks up when she sees me. I have no idea why she calls me "Zootie Bang" but if it were a sign of disrespect, she wouldn't be aiming the joint between her fingers in my direction. The friend beside her, also in a hard hat and dusty work boots, pours beer from a bottle in a brown paper bag into a cup, and I accept another award for being the weirdest girl that ever lived before I prop myself up on the bench rest next to her. A light buzz is creeping up on me when I see this chick who has a toy poodle who uses a dildo as a chew toy. The last time I saw her was at her apartment near the Clinton-Washington stop on the G. We were going to a party. Before we set out, I flung open the door to the bathroom thinking it was empty and found her with one leg up on the sink wash-clothing her twat like she had big plans for herself later. I'm wondering if I said "Hi," right now if she'd be embarrassed or even remember that awkward moment when a boy suddenly jumps to his feet from the bench facing mine. Another one slamming a ghetto blaster down between them and hitting the play button. The walking bass line to "Love Break" easing in as a sense that we're all in danger, but in a good way starts to build. The two of them circling each other. Faces deadpan. Demonstrating the art of the tease. One in a sheer low-cut shirt with arm raised high and taut, snapping his fingers. The other stalking him. Shoulders

thrust back, hands on hips, taking his time. Both spinning. Shuffling with palms towards the sky, oddness on overdrive. Irrepressible attitude. One minute war, the next a spoof. Bodies doing anything they want them to.

"Werk ladies. Werk," someone yells, tossing a rose on the ground in deference to the gods of couture and ateliers. I've totally zoned out though when, "Five-O," one of the female construction workers warns under her breath while a police car that has subtly hopped the curb creeps towards us through the tight space between the benches.

"Five-O," I murmur to someone near me.

"Five-O," everybody's repeating and whoever can, conceals their liquor and snuffs out their joint before it's too late. We all know the drill, including the cop gliding through tightening his eyes at us when he's parallel, to drive home the point that we're all under surveillance.

Stacy rushing across the grass behind the bench where I just got faded.

"Hey. Long time," she says, pointing towards a throw blanket her boyfriend Malik is on. Washington Square Park dropping at me from such an odd angle it looks like some other place once I get past how manky the grass is and just sit. I met Stacy outside the Loft one weekend. She and Malik taking me in that night as their guest. Asking them how they became members, however— that was a waste of time. They couldn't stop guarding the, "If I told you, I'd have to kill you," secrecy of Dave's party. "Around the way" kids that downtown "it" spots don't let in, being the beautiful people for once and loving it. I got it. But was tired of not being able to just pay

and enter when I wanted, so I'm delivering a package on Prince Street when it occurs to me that the Loft's right there and knock without even really knowing if it's where Dave Mancuso really lives. Him sticking his head out almost instantly. I want to become a member, I tell him. Giving him my name, and I've got the black and white ID card with an image of the Little Rascals on it within a few minutes. Aries complaining after the first time I took him there that Dave was this long-haired messianic cult figure conducting some kind of weird experiment, but the fact that the Loft doesn't have a bar is what ticked him off the most I think. Potato chips. Hot dogs. Old school party balloons. Bowls of fruit punch. The side by side men and women's dressing rooms where everyone changes from street clothes into workout gear before dancing. Dave's sets so happenstance. Boys baby powdering the floor to accelerate the speed at which they spin, girls peaking on two for five gremlins clutching their heads the better to process "I Want to Go Bang" by Dinosaur Jr.'s over the top prog rock jazz madness.

Malika and Stacy finish off a box of pizza. Best Sella with an aura that simply gleams crouching on the grass next to me.

"I've known him since high school," Stacy says, pecking him on the cheek. "Right Malik?" she asks. Malik rocking his head. He and Best sella bumping fists. This is the first time we've ever met, but as cliche as it sounds, there's a deja-vu thing between us that I'm feeling. He's a promoter. I've always wondered what exactly that involves or why young 'bruthas are so gifted at spreading the word without a budget. Any late seventies under-

ground spot of legend, Best Sella was behind its success. He's back in New York for the first time in years now though, was in England where he had branched into managing a couple of singers he describes as "major talents." Usually I'm turned off by discussions about music in which the word "hit" has any significance. But there's something I like about him, especially once the sun begins its retreat, leaves giggle in the breeze and our conversation drifts.

Delivering packages is a straitjacket. I escape its tight grip by cutting through the park and touring the secret world of outliers clever enough to survive without the restrictions I want to free myself of but haven't yet. There's the kid always next to the arch that sells so many balloons during the summer, he spends winter in Thailand on the beach. There's Charlie Barnett. Funny as hell, but too real for Hollywood or TV. The fountain's his Colosseum when the water's off. Kids gathering around him chanting, "Charlie. Charlie." Him conducting them like they're his orchestra as "Charlie. Charlie," they shout louder with more feeling until an audience of a hundred or more have formed a ring around him within minutes.

"The KKK wants to march through Harlem. They're waiting for the permit." he shouts out in a voice with the range and power of a megaphone. Pausing, working the silence before saying," I hope they get it. We could use the sheets." Reckless laughter. Ear splitting whistles following. Passers-by rushing to be part of something that seems better than the usual. Him making sure that everyone puts cash in his hat.

"He would've been part of the cast of Saturday Night Live if they hadn't decided to go with Eddie Murphy," a fan still rooting for him to get his big break says in my ear. A girl usually on the grass on the LaGuardia Place side of the park who keeps $25 bags of high-grade smoke tucked between the pages of a textbook is who I check out next. A man is following her instructions to sit down beside her as if they're friends. He waits before finally paying her and rushing off in disbelief he had to jump through so many hoops to smoke a doobie. The Rastas by the fountain stash Ses and lambsbread under stones and bushes. One named Hylton spiking a ball from his forehead and catching it on his knee before dribbling it towards a wastepaper basket and diving down to tug a half pound of fluffy green weed from under it.

Best Sella on a bench facing a row of fancy townhouses. I'm surprised to see him again. I know he wants to start his own record label in London but didn't realize he was raising the cash to get it up off the ground by selling weed—but that's what he's doing hey as he sits there so freshly laundered smelling, spooning butter pecan from a Haagen Daz container and browsing the sports section of the Daily News.

"Smoke, smoke," he says just above a murmur each time someone passes. A man who could pass for an NYU professor handing him a ten all of a sudden and I think damn because I'm not making close to what I need and am restless as always.

"So how does someone get started doing this?" I find the nerve to ask. Looks easy, huh?" he asks back like he's talking to a scrappy younger kid.

"As long as there aren't cops anywhere, yeah." I answer.

"Well. Looks are deceiving," he disagrees for my own good.

Maybe he's in a better mood. Maybe he thinks having a girl with him helps because he doesn't mind my going with him to an appointment in a bar a couple of steps below the sidewalk, with a forgotten quality to it on 14th near Third where we take seats at a booth without ordering drinks. The customer's arm fading below the table to pay for the product Best Sella subtly hands him. Me closing my eyes mentally. He's a go-getter, making the world do what he wants it to, not the other way around. At times it feels like we're dating. Laughing shyly, but with deep eye contact during an idyllically greasy Cuban Chinese meal. I've already quit my wack messenger job when he says okay, this is all you have to do. Aries puts up the money. Best Sella and I agreeing to meet in the park at which point I'm supposed to hand it over, and he'll buy my first starter bag of weed with it. I'm too early as usual and waiting when this power drunk cop stomps by handcuffing Fuller and dragging him along the ground by his locks like that's what they were designed for. Fuller limp, not resisting, back flat against the pavement in surrender.

Babylon runnings.

All's clear except for sightseers and a juggler. The usual posse of dreads later coming back with their tantric

sex goddess girlfriends with cannabis in their strollers instead of kids. Best Sella warning me for the nine hundreth time that I don't want a police record. Okay. Okay. I'm with you, I say. It'll be decent grade, not the best, what I'm going to get. You don't need the best. The people who buy from you—you'll never see most of them again. He says, taking my money, saying he'll be back tomorrow same time, same place with everything I need to go into business. I'm ready to start my new career, waiting for him on a bench near the entrance where old men way too down and out to live in such a high rent area always play chess. But Best Sella's a no-show no matter how long I wait. I walk around, hitting the usual spots around West Fourth where I'd normally see him, but no luck.

"Why so down? Not like yourself," a dealer everybody calls Above the Sky says inspecting me from over the top of the round sixties style sunglasses hiding his bizarrely small oval shaped face. He's on his bike as always, pedaling around, casing the surroundings, mumbling, "Red and purple. Red and purple. Right here. Got 'em." I tell him how I handed over all the cash I had to somebody that was supposed to help me and how that's left me up a creek without a paddle.

"You can lose a lot of money out here," he replies. Taking a cough drop tin from the grungy bookbag he's wearing, he peeks over the top of his shades first. Shakes some red stars into my palm and says: A little gift sis.

After a week of looking for Best Sella, I give up. If not for the dogs moving in hyper circles around me, I'd stay

in bed eyes shut, knees to face, unborn and not budging. But the park draws me back towards it and two weeks later, I'm there again listening, watching when I hear an interesting conversation.

"Now Stanley he was one of the great con artists."

"People put money in his hand. Lots of dough. No second thoughts. He won their trust."

"Stanny Stan."

"Stan the man."

"Now Stan was a legend."

"He was."

"The hustle he did with the vacant apartment?"

"Heavy."

"He got the keys, advertised it in the newspaper. Took rent and security from like five, six different people that wanted it. When you're too stupid to check and see if you're paying an actual real estate agent, that's you."

"Nobody ever came looking for him either."

"How much did he clock do you think?

"Four or five grand? Then things got hot. But hey, nothing lasts except for them making money off shit we get locked up for."

They're not ghetto flower children, are business casual. Frustrated go-getters. Romanticizing someone who made cash by any means necessary. Meanwhile, I still don't get why pennies, nickels and quarters are any different from screws or thumbtacks. Change tumbling from my pockets when I get undressed, rolling in different directions and not worth chasing and cash, well. I confuse it for receipts, throw it away all the time by mistake. Maybe all I had wanted was for Best Sella to con-

vert me into a capitalist I think after running into him later the same day. This is what happened: The police rushed in with their sirens on blast and scooped him. They catch you off guard, shoving as many kids that have drugs on them that will fit inside vans. Friday sweeps. You spend the weekend in a cell at the sixth precinct. Monday you're free again. I've never been busted during a raid. I've been lucky. He laid low after that, sticking around his girlfriend's and trying to re-up on the smoke and money the po-po confiscated.

"Let's take a walk, yeah?" He says.

So we walk until we reach a block in Soho desolate enough that it's safe, sit down on some steps and he gives me the bag of weed finally.

"I thought you'd run off with my money," I tell him.

"Maybe someone else's, but yours never," He says.

It's a Saturday, the day of an arts and culture festival. Tourists take pictures of the Empire State Building without needing it to be there. Nothing happening beyond the usual. Balloon Boy's back under the arch, making a killing.

"Smoke, smoke right here," I say whenever I find the courage. An older lady with hippie bangs in a sixties style embroidered chiffon shirt pausing finally. I show her the bag in my hand, hold it to her nose.

"That it? Nothing harder?" she asks with a grimace.

"What do you mean?" I ask in confusion.

"No Black beauties? Coke? No speed?" she checks. I apologize, telling her I'm no help when it comes to that stuff and ask if she's okay because she seems stressed

out or something at which point, she leans her mouth towards my ear, shows me her badge and whispers, "Look, we're doing a sweep. I don't want to bust you. Just go."

I rush to the other side of the park instead though and tell Best Sella.

"Split while you have the chance," he advises looking over my shoulder to make sure that she's not following me to him.

27

If it's not the police, it's all the dealers competing. You need to be aggressive or been around long enough to have regulars, so Christopher Street's where I head next and stay in the coming days, knowing the Rastafarians and macho boys who hold down most of the sales in the park wouldn't be comfortable on a block of bars and shops that cater to gay men. I wouldn't exactly say the dealers on C Street are carefree. But they're not heavy hitters either. Prestige has the chest of a beast. He bench presses. When he smiles, he has dimples. Men done up like cowboys and Nazis who strut in and out of nearby drinking holes take a liking to him especially when he's shirtless with his doo rag spilling down his back like a young pharaoh from the so and so dynasty, but the other dealers don't have time for cute. Prestige sells wack. It casts doubt on what everybody else has, I've heard a few say. He cuts pictures out of the packets of sugar in the containers on the table in a booth I sit across from him in at the Sheridan Square Diner one day. Moving fast, using a razor to create what looks believably enough like tabs of paper acid. That's when he gives me his recipe for fake mesc: Boil spaghetti until it's al dente, chop it up and dye it in food coloring. A strange thing to confess, but he'd aged out of a boy's shelter not long ago and isn't about to be out on the street broke, he said.

Rust never stops reading the traffic that runs west towards the Hudson or east towards Seventh. I have no idea what he even sells. He never smiles, plays it so close to the vest.

"DT's," he'll say like he's sleep talking.

"How can you be sure?" I ask.

"Unmarked car. Two in the front, one in back. Big dudes. Huge assed necks," he answers.

Junky Marvin's old. Walks slow. Conks his hair. Swollen hands and ankles swell over the sides of his sneakers. He's rehabilitated. Not a junkie anymore, so they really shouldn't call him Junky Marvin but there's no malice intended. You get caricaturized out here. It's not a big deal. Valiums and other prescription medicine you'd pay triple for if you went to the pharmacy, he sells that kind of thing. You could stand right next to him and think you're alone, he's so quiet. The exact opposite of Marv in the Kufi reading to everyone from the newspaper and linking heinous crimes to passages in the Bible.

"I keep telling people it's the end of days," he sighs before checking out the sports section. He sells a little of everything.

Eileen pulling along by a cane delicately, with caution, covering the area between the park and the piers, selling two for five mesc. Everyone knows her. She's been out here for years.

"Hope it's a good night. Yesterday was dead."

"Really? I heard the park was alright." She replies.

"But it's more chill down here." I say, unable to believe she could ever really like how I'd shown up all of a sudden on a street where she's always been the only female dealer.

"What do you have? What do you have, Miss Fabulous?" men in and out of the bars already stop and ask me. Hamptons tanned pretty boys in an open top Jeep scooping me off the corner and speeding off to a more

quiet corner where nobody's watching to buy a couple of dime bags from me. Not that I'm trying to be popular. That's just how it's turning out. Then, time stops or that's how it feels this night that I'm alone on the corner of C Street and Greenwich.

"Must be something special happening I don't know about," Eileen remarks approaching.

"The world's hiding," I suggest, a novel thought lighting up her expression when she says: You know what? I'm going to do something I haven't done in ages. A hit of my own mesc 'cause I just feel like it."

Nothing wrong with that," I agree before she shakes a purple dot from her palm into mine and the watered down version of a sixties hallucinogen brings all the wonders of a lava lamp to a night without sense. The anxiety I had about her resenting me dissolving during the hours that we sit side by side under the hypnosis of clouds rolling back and forth. Eileen more relaxed after that. Laughing at my antics and accepting that I was just someone else who'd washed up on the shore of the river like the two runaways from Arizona who had recently shown up and this exotic male prostitute who likes to kick it on the stoop with us.

Enter Shiny, a mariney yellow dude no one could ever mistake for bright, only he isn't slow either. Coming alive with a blinding fascination for everything Eileen introduces him to now that he's her boyfriend. I get along with him. He laughs the first time we meet before I even say anything like maybe she briefed him on who's who, and her description of me was that I'm "funny."

"Gotta make some money," Eileen says limping in circles, looking pressured but with a lightness about it. Shiny rubbing his arm across the sweat on his face, head bobbing, saying: More shrimp and Grand Marnier margaritas. Now that's all I'm about. The delight he shows when talking about the meals they have together putting the biggest smile on her face I've ever seen. Eileen happy even if she's footing the bill for the fun things he's always saying he wants to do again. Resigned to the fact that Shiny's who you end up with when men have never shown much interest and you're lonely, I overlook what an obvious moron he is. Then, I arrive on the corner of Greenwich and Christopher one night and find out that Shiny lost his temper with Eileen and struck her. Blood everywhere. Dealers rushing to scoop her teeth up from the ground. Putting them in a cup of water. They took her to St. Vincent's. Don't want to see that punk back around here, Rust says when I run into him. Eileen limping towards me down C street the next day. "He broke my jaw," she says, suffering to speak through wires and braces. In her hand a cement filled pipe she says she'll slam Shiny in the knees with if he dares come anywhere near her, carrying it with her wherever she goes the next few days. The sun has fully set when she and I are trying to earn a few bucks. The whole Shiny situation's supposedly behind her when don't you know he's there in the halo of a street light like some mutant villain no one but a superhero could defeat. Eileen stands. He's in front of her, his shadow dropping over my head and falling around my feet so it's like I've been erased am not even there when he orders her to put the pipe down the way you'd

command a dog. Her obeying, shoulders bent, walking off with him to talk privately. Back in her life again. That simply. Accompanying her when she does her rounds, telling her what she's not doing right, like he'd know. Rust and Marv with the kufi sizing him up at times a certain way.

The last night of the year. My last chance to earn some of the back rent we owe instead of going to the court-house on Centre Street again to fill out papers to delay getting evicted. I had imagined I'd be running from car to car counting cash, closing sales. But the rain hasn't let up once all day. In an hour, it'll be 1983. No one's out though except dealers consoling each other. Eileen and I under umbrellas, sipping flat seltzer that's supposed to be champagne. Shiny, unable to accept how hopelessly dead the corner we're on is, saying he's going down to the spot next to St Veronica's where Rust and them always stand. Down there it's better, he declares. But he's back much faster than he intended in a blood soaked party mask with a gory eyeball bulging out of it, which might have made sense on Halloween, but it's New Year's Eve. Blood mixing with the rain dripping down his face, he goes marching into the distance with Eileen. Rust and Marv in the kufi telling me later that they were tired of him cutting off their sales, so had used a set of brass knuckles and Eileen's discarded cement filled pipe to teach him a lesson.

I would've preferred to never have run back into Shiny, but one morning I take a seat on a train whose destination might as well be hell because there he is

smiling, and I'd be a fool to confuse those limpid asking eyes of his for a sign that he's changed. Rocking by the straps, talking to a gray-haired man in a jacket and tie seated next to me.

"He didn't have an easy life. I'm surprised he's still alive," the man leans over and mentions after Shiny gets off at his stop, and my best guess is he was once Shiny's social worker, but morning's an epidemic, a morgue, a fortune teller—a phantom, a microscope, a broom like Washington Square Park where I like to sit by myself in the wee hours coming down from the usual hallucinogens as rats hunchbacked, nervous with their claws pointed riptide every inch because morning's a concierge too. A bad case of acne. A coat of arms, eulogy, onyx, asteroids, fresh cream and apricot even.

Early one mildly sunny balmy afternoon, a procession of pretty boys moves towards the riverfront.

"Loosies. Loosies," I repeat.

No other dealers serving Christopher. Just me. I've never had much luck at selling dime bags. A dollar's a helluva lot easier to ask for, so I'm grabbing cash faster than I can put it in my pocket the same as my idol in the park who sells balloons. Then, the person I've been fearing since the moment earlier when I started to run out of weed when I was rolling joints and decided to stretch what was left with oregano appears and lights up to test the quality of my smoke. We're shoulder to shoulder when he exhales a telling bouquet of spaghetti sauce into the air. Not knowing how to react if he accuses me of selling wack, I'm running scared, but "Mmm. That's

some good shit. Give me a couple more," he says. I'm sold out. In only a couple of hours, I have a hundred single dollars bills just like that, but morning is zero, so this gimmick will never work again.

Down on Edgecombe and 145th they peddle a piss poor strain of weed that grows between crushed glass and fallen brick. It's the new spot to cop. Talk about violence. They're intense. Doing transactions there is ferocious, not fake. Constant disagreements about who owes who money. Gently tapping a bottle against the curb, some psychopath methodically removes the base, then lunges forward, growling "bumba claat" and grinds the shards into another man's face. His victim not reacting, just standing with his hands on his hips profusely bleeding afterwards as it occurs to me that demanding that the men in my life be more sensitive, forces them to compromise the pressure they're under to not feel pain. But I don't buy out in the open. I go into a building on the same block in which every apartment is occupied by different warlords that protect the weight they sell with meat cleavers and Uzis. I won't be around luckily when the police raid. I just know it'll involve helicopters and a swat team unless they're insane. I have no idea where the actual tenants went, but I climb the steps until a dread with the spooky countenance of an obeah man appears at a door and invites me in to sniff the weed in an open suitcase on the floor of an unfurnished two bedroom. Grumbling in shantytown English, but softening the price when he realizes I don't have much to spend. My plan is to buy from him on a steady basis. But the

next time I climb the stairs, he's not there. I don't hear a sound or see anybody until a voice behind another door calls out for me to slide money into a slot on the wall beside it, which I do once we agree on the amount they're going to sell me, sum likkle bag damned near empty what they push through. Pounding and shouting my whole life story so they'll understand what's at stake. Them pushing my money back out just when I've given up and am about to walk away.

The migration is East tonight on Christopher past the bars, Dave's Potbelly and the Haagen-Dazs next to it as most of us move in the opposite direction of the patrol car lights probing the black hole of the harbor. It takes only one clown to mess things up for everybody else. Some diva named 'Twan poking his finger in a boy named Andre's back, pretending it was a knife and taunting, "Jump bitch." The police lifting Andre out of the waves. An ambulance rushing him to the hospital to get a tetanus shot. At least he didn't drown, says a girl with the cutest ink tail dangling down her neck. Twan belongs to the House of Versace and Andre to a rival house that hates them, what I hear later, but nobody comes to the Village to fight, so the bass quickly gets back to banging for the dainty chosen boys along the pier who Arabesque and death drop with rounded torsos like nomads performing a sunset ritual.

28

There are two worlds: day and night. Day's the enemy of freedom, but night is a blindness that benefits us. A balancing out. A moment when the meek inherit the Earth and go beserk. A power move. A coup.

I'm a fake street hustler, depending on instinct too much, just winging it is all I'm good at. Money, I resent the importance it has and am always kind of bitter about the pressure I'm under to work instead of being able to sit on a pissy palmetto bug infested stoop and share my opinions with anyone who shows interest. I earn $20 and spend it. Empty my pockets fast as if I don't want money anywhere near me. Like money's bad luck or something. I don't feel that way consciously. I'm saying that's the way it seems. Every time I ate a slice when I was younger, I felt lucky because I was always worried I'd lose the right to eat pizza due to the grotesque politics of place in this country. I get burnt out from the espionage with the cops and the walking around looking for a good spot where I can sit without being watched through binoculars. In the calm of a warehouse driveway on Great Jones I'll eat a Sicilian sometimes and become one with the garlic and grease or hide in this cafe on MacDougal nobody but me seems to know about with only two tables and a huge cooler of rose petal flavored water. You drink that stuff and go on a pilgrimage to a holy site, especially if you have the munchies. No shit. The falafels are something, and I'm eating one right now that's like the best I'll ever have. Sour sweet rancid smooth rough creamy.

The kid at the counter having put avocado, beets, feta cheese, dried fruit—as much as he could fit inside it. It's this paradox of sensations I take my time chewing before I order a glass of tea. Sip and turn the pages of *La Familia de Pascual Duarte* until the text dissolves and I'm in the dining hall in college again, eating alone under the watchful eye of the black table where I had sat only once before returning to my senses and deciding not to cooperate with the pressure black students were under to huddle shoulder to shoulder over meals. The only thing justifying carrying my tray towards a bunch of do-gooders I had zero in common with, being a vision ingrained in the human imagination of unrelated blacks cramped into the cargo areas of ships, which may be an overly bitter observation—though saying that we'd been selected by admissions based on our ability to make the best of being stranded is just telling like it is.

"I've been assigned to help you feel at home on campus," a black junior at my door obviously recited from a script. I was already rebelling style wise in the first days of the semester by not combing my hair, exaggerating my slouch and wearing shirts with the sleeves cut off. She, however, had on this polite little outfit and Ben Franklin eyeglasses. Was straight out of a test tube in the African-American Dream Lab. As soon as we met, she was freaked out. It didn't help that she hailed from some part of the U.S. more foreign to a New Yorker than Sicily or Trinidad. Nothing about her was familiar enough for her to have been handpicked to be my guide during Orientation Week. In fact, accompanying her that day was so similar to grunting and groaning up the side of a cliff with my bare hands that by the time we were seated at a

gospel choir performance in a house a short walk across the lawn, watching Black students in church robes sing negro spirituals to white administrators clapping in time with them in delight, "Drop," a voice in my head whispered, "and that's what I did.

At least I still have "La Familia de Pascual Duarte," required reading in a senior seminar in Latin American literature conducted in Spanish that the visiting professor from the University of Havana teaching it gave me special permission to take. If someone that society had written off as a monster put a knife to the throat of a Poet Laureate and forced him to write his life story, it's the strangely familiar missing truth you'd get and the only souvenir I have of the three months I wasted trying to do what everybody else was after high school.

"Now you know this is not what I ordered," Aries bitches, blaming my incoherent Spanish for why he doesn't recognize what's on his plate.

"Queso de freir, mangu, longaniza. Eat," I command with my mouth full. Him eyeballing me back with unfazed attitude.

"Tell it to the Marines," I recommend as we're stumbling home later, both of us still acting the fool. Singleton's is one of a few soul food restaurants still standing, but nobody eats there anymore. The fewer customers they have, the longer the food sits.

"The collards taste old," Aries complained the last time we went there. Aries—he can make a whole feast out of a can of jack mackerel in tomato sauce and a box of pasta, so sometimes in the wee hours when we're

starving, a quick trip to Ojo del Agua bodega is the best idea. What we do when we're too wasted to realize we're drunk already: Descend One Four Five to a storefront in the valley where there's nothing but a couple of boxes of detergent and rolls of toilet paper on the shelves and grab a bottle hidden behind the counter God bless them because not selling liquor on Sunday is a sin.

"We should've seen if he had gin," Aries is saying after we've already reached the corner of Convent, but are heading back down the hill again one Sunday as the sun's just rising when Sylvester the great disco legend's rising towards us in a windblown garb with the message that the battle between the norm and the restless is over and we've won, across his face.

It's a wrap once the masses close in, a dealer outside Paradise Garage pontificates counting his cash. Remember how much we'd clock back in the day? You couldn't compare the crowd inching towards the door now to the black fashionistas so far ahead of everyone else that top designers in stealth mode would sketch pictures of them from blacked out windowed limousines. A rare kind of sexy. Better drugs. The same glorious lightning that struck every week. I didn't come here then, but know the dish. Best Sella dips through the traffic jamming Watts now, asking if I want to go inside with him or back down to the piers. We haven't hung out in some time. Let's go, I say following him in. Handshakes suffice with the crowd control team, old running buddies of his, so I don't have to pay and that's great. Looking for a guy named Niamey. Money to be made if he finds him. The whole urban free love cult in full force. Figures radiant. Rippling. Up-

town faces I've nodded off in the same subway cars with in the wee hours now and then. Best Sella pausing to talk to a snooty girl he says is a producer who I overhear say "Larry," like he's just someone she's done business with and not the force behind this erotic deja-vu moment without end we're immersed in. Best Sella knows what he wants isn't going to happen. Not tonight I guess, he says, so we creep back out, smuggling illegal quantities of Chaka Khan with us into the pre-dawn street. What a ghost town Hudson is. Nobody else is around. An off-duty taxi rolls by. That's it. But homie's still all about his money. Grabbing a public phone as soon as he sees one to call an insomniac who lives on Waverly who can only sleep if she smokes a little first. Best Sella never gives up, is relentless. He's leaving for England next week and I don't know when I'll see him if ever again, so hurry to her crib with him before we're sipping diner coffee through plastic lids in a car on the uptown D in which we're the only passengers and just as I always do in the early hours when the train stops at 145th I ask him if he wants to crash with me, since he's got a long ride left. Him taking me up on my offer for once, finally. I shut my door, locking my dogs out. We get undressed and sit naked on the floor in my bedroom without any furniture except for a mirror that's fallen so many times, a map to a land where no one's ever been runs through it and when I rest my head on his shoulder and he places the most flawless spliff ever crafted between my lips, my mind floats back to the electric fireplace I spent so much time in front of in Birmingham being that anything I do in New York I can tie to a city where the young once tried to mash down the empire just seems more valid.

I'm ugly. Something I find startling each time I hear someone say it, which is usually a spoiled glamour girl upset by the heavy conversation I'm having with her boyfriend. Once, a man I walked past on 125th and Lex frowned, then called me "fea." The two of us awkwardly bonding as I scrutinized him for the reason he'd chosen such a vicious way to break the ice. But ugly is a rare form of beauty or tourists wouldn't point their cameras at me. Fashion operatives wouldn't thrust business cards in my hand. The lady who said she worked for Essence Magazine asking if I wanted to be part of a photo spread of women with dreads would have had to have told me how much the pay was right there and then for me to have dialed the number she offered. Resting on a car in a garland of botanica beads, saggy vintage men's trousers and a washed out t-shirt without sleeves as I stand in front of Badlands on C Street talking to Louie and Sherise, who I haven't seen in a long while though, I'm feeling just fine and free of the curiosity of people who make me uneasy. That is before the police show up.

"Come on," Sherise says.

"I would start walking if I were with you," Louie advises out of the side of his mouth like a ventriloquist trying to divert attention from himself before he rushes away as if we have to avoid the cops even if we're just talking about how nice the weather is, which was not illegal the last time I checked. But I overestimate my ability to read situations when maybe it's just better to do what everybody else is because no sooner than they run off, "May I ask what you've got in your pockets?" an

officer looking me up and down with a curious expression, asks. He finds what he finds. The weed first. I forgot about the pills. Eight black beauties a dealer I hardly know had talked me into taking in exchange for two nickel bags. The handcuffs come out, the flat part that rests against my wrist kind of hurting. They tell me they need to find a female officer to frisk me, cruising in and out of the surrounding blocks of prissy townhouses with flower pots on their steps like they've got all the time in the world. No siren on, asking how long I've been on C street. Making small talk in a way that's straightforward, not a major power play. Who do you know of that sells anything heavier than weed and pills? Like heroin? The one whose driving asks watching me with special interest through the rear view mirror. That's not what guys strolling down to the piers are looking for, "Come on," I say laughing.

"Yeah. True," the other one answers.

"What about guns? Whose got any?" his partner asks with a dumb smile.

"Kids get buzzed before they head to the clubs. Men cruise each other. It's not heavy like that out here. Come on," I say. They nod in time, suddenly falling silent. They must be avoiding doing real work by zigzagging the safest blocks in Manhattan and making small talk with me I've decided when a female officer without a partner pulls up. I get out of the car. She's a wild one herself who I think I might have run into when she wasn't in uniform. Either way, she'd light up with me in a heartbeat later I can tell when she searches my tits like she thinks it's too soon for heavy petting. The whole ordeal is so kooky and

awkward, she's picked up on it and is too freaked out to lift the legs of my pants to search my socks where most of what I'm carrying is hidden. Then, I'm back in the car, asking how long I'll be in a cell and if I'll be given more than bread and water because I'm hungry, which makes one smile and the other shake his head and I've gotten out of the car in the parking lot at the precinct when they tell me to turn around, remove the cuffs strangling my wrists and say: Just stay out of trouble, kid. We're not taking you in. I'm in a rush to pick up where I left off so don't spend much time thanking them, just say goodbye a couple of times before I hurry back towards the river. The night is young. Junkie Marv's the first person I run into. Word having spread that I'd been put into a police car, no doubt, I figure he'll ask if I'm alright but "No. I'm not falling for that," he says raising a been there done that palm to discourage me from coming any closer. Every dealer I run into treating me with the same disrespect as it gradually occurs to me that they think the reason I'm already back on the street is that I turned and am helping the police to bust people.

29

Riding a bike for Good Rush in Chelsea. The monotony. Mere pennies I make in the heart of the nine to five rat race delivering letters and packages. Every time my life makes the slightest bit of sense, I chop it to pieces, so needless to say, The Guerilla Girls are history, though I haven't entirely stopped making music, am in this on and off project with Motor C., out jazz horn players, guys with synths. We rehearse at Charas, a former Lower East Side public school. I've performed at Neither Nor, the Shuttle Theater and a couple of raw fleeting spaces without names. Written some of my best songs to date lately. Songs with poignant choruses and memorable lyrics, one called "Witness to Violence" about the obligation to act that knowing about something that shouldn't have happened gives you. The only time that performing live will ever feel like I'm serving a concrete purpose will be when I sing it at a benefit at Danceteria for Michael Stewart, a young inspired graffiti artist beaten into a coma by transit police.

I was still subletting Alexa's apartment and sleeping on a mattress that Jean Michel had vacated, the first time I saw the Bad Brains tumbling down the steps into an open cellar on Avenue A.

"God save the helpless instruments they're throttling the last breath out of as well as anyone who lives nearby trying to sleep," what I'd think any time I'd hear them play. A new Afrocentric coalition's carefully plotting to integrate the Lower East Side gig scene. Meanwhile the Bad Brains are a posse of outlaws with a maniacal Rasta

punk ideology that fell from the sky into its pack of feral mostly white fans. Biking from Washington Square Park to their rehearsal space at Westbeth early evenings I try and sing over their arrangements in spite of my aversion to heavy action guitar. Doc and Darryl are wise crackers. Mischief incarnate. We hop on an uptown train to Columbia University to see HR perform with another band he's in for a minute. Bolt though a turnstile, rush through a dead zone just south of Harlem together, and it's like I'm an out of control teen again outnumbered by boys egging me on to race the one who's fastest. Hanging out at Doc's crib with his wife and kids. Laying down vocals over a song that the musician who introduced me to them remixes without ever believing for one minute that HR is gone for good or that I could ever fill his shoes.

In the heat of an argument in a hall on Avenue A with a boyfriend I was starting to realize was in monogamous relationships with like four, maybe five other girls as well as a couple of men, a petite punk neighbor of his lunged out of the door of her apartment shrieking, "You're a nigger! A nigger!" at me during my emotional exit from his apartment. The odd plot twist here is that lover boy was also black but an insider known by the other tenants for being good at repairing runny faucets. Maybe he was banging her too. I don't know. I must've removed her tongue from her mouth with a surgical knife 100 times in my imagination but have never been a violent person so am incapable of becoming one even when appropriate. As for the word "nigger," it's inescapable in America. You're wasting your time if you think you can outrun it

just by hanging out with people with radical taste in art and music.

I bounce from east to west, uptown then downtown, then back up again. The only thing that matters when I get off the 6 train at Astor is that Motor C's is near. Her apartment's still my sanctuary. Cuddling her bass, playing some dub riff on it and humming as we take turns trying to solve the mystery of men, talking each other off a ledge or bracing ourselves for something better. Always, ultimately laughing at how tacky reality is and relieved that it's never had much to do with us. The crates where she used to keep records now jammed with instrument cables. The 808 drum machine and four-track tape recorder. The SP 12, Korg. Voyetra. DX-7 and other once must-have machines sold or in a closet. I'm a sucker for songs that make me feel like I'm in a movie. White noise. Hand claps. The latest special effects, at the same time that I notice that we're all falling under an evil spell of blinking cursors and glowing screens.

Lately, the joy of just winging it has been replaced by a rising anxiety that unless you have a trick up your sleeve, the end is near. But success is unnatural. Nothing proving that more than Jean-Michel of all people shouting my name from the other side of St. Mark's Place and jogging towards me as if he could save himself by speaking to anybody he recognized who hadn't been mentioned recently in the gossip section of the New York Post.

It's 1984 and the East Village isn't the ghost town of my teens. Young snobs drawn towards urban blight

continue to flood in, each wave less art damaged than the last. Fast food restaurants with Coney Island style awnings have replaced the hippie cafes and bar that advertised a 99 cents chicken dinner that was actually a hard-boiled egg. Homeless psych patients clutching styrofoam plates from the nearest food kitchen lost in a maze of members only gardens inside padlocked gates. Thank God Motor C's apartment really hasn't changed. Visitors still ring the buzzer, climbing up to her living room like they're boarding a rocket to someplace better such as Snuky Tate, the artist behind the cult record, "He's the Groove." Barrel chested with eyes that bug out of his head when you express an opinion that differs from his. He dressed in drag in San Francisco, according to rumor, but has settled into an any old sneakers, jeans and unkempt dreads look, but a lot of us are less fabulous and have entered a more introspective phase. Snuky never misses the subtlest gesture that swings the balance of power in his direction. He pontificates on shit others have got to notice but aren't vocalizing like how rhymes and breakbeats make rock and roll sound snooty or Greg Tate is bringing Harlem and the outer boroughs to the Village Voice newspaper like never before and since the Village is just a Bohemian museum without the misfits of color from Queens, Brooklyn and Jersey electrifying the "Cage," the park, the piers, Tate's more of a spokesperson for a lot of us than a reporter.

"I had to hang out with my white friends if I wanted to listen to the blues when I was young in Delaware," Snuky complains, playing defense one second. Then offense the next.

"But the comfort that white audiences derive from listening to the sagas of black folks without a pot to piss in or a window to throw it out of raises red flags," I say before picking his brain for insights into why I don't like being on stage.

"The minute you're up there, and they're down there, the balance of power instantly swings in your favor," Snuky reassures me.

"Yeah. But that's the problem. I don't want all that." I say.

"Okay," he goes, coming at me from another angle without citing Artaud or Stanislavsky thankfully, and it's cathartic but doesn't help.

I'd read about Joan Littlewood's radical traveling theater when I was in England, which had helped me to realize I'm an agitator. Not an entertainer, but I'd always been offended by the fan/star dichotomy. Stuck with songs that aren't meant to be sung and texts that aren't meant to be read. Lyrics and notes inked on stray pieces of paper in my always changing handwriting keeping me in suspense. Why am I so compelled to record how I feel about everything? Should I be giving such a dead-end compulsion even more of my time and attention? It all just comes down to dedication when I talk with free jazz musicians. Now that the Loft Jazz scene has atomized, Daniel Carter, Jemeel Moondoc and other horn players who tend to revere Cecil Taylor are suddenly on the same shabby couch that used to be my bed slurping tea between Motor C's steadfast rock and reggae record collection.

"What Cecil wants from his musicians is loyalty," says a flautist named Bernard, a true Cecil devotee, still fig-

uring it all out as he reflects. That arm paddle. That bop. That snide out the side of your mouth way of talking that my father and his musician friends have passed down another generation. They're men who've studied and taught composition and theory at the most prestigious conservatories in the country but an audio engineer I know simply refers to as "jazz bums." Charles Gayle who's strategically homeless and unemployed in order to live as one with his sax may fit this description but is also someone any critic worth their salt considers a genius. The stubborn romantics who drop in from Beirut, Dakar and other parts of the world eliciting raised eyebrows as they lay witness to life off the beaten track. Louis Sarno's home is in the forest of the Central African Republic where he lives with a Pygmy wife whose tribe's otherwise soon to be extinct music he's recording in spite of the malaria and intestinal parasites that come with such a commitment—we'll meet at Alexa's. Voices, especially those from childhood advising me that when things aren't working out for you in the country you're in, go elsewhere—will play a part in my decision to donate what little I own to charity, hole up in cheap foreign rooms and defend my calling to write for better or worse, but I'm light years from any of that when Cassette, who I haven't seen in ages, knocks at the door of my Harlem apartment, hurrying through the shadows of the unlit hall with my dogs scuttling between us, saying she wants to share some opium she was fortunate to score. Riding so far to hang out for only a second. Go figure. Hunting through a tote bag for a ball of something she runs a lighter flame across like a birthday party

magician performing a coin trick until I'm alone in the dark revisiting daddy in silhouette at a table with a glass of brandy brooding. Blank pages of Ibsen's *Wild Duck* and Strindberg's *Ghost Sonata* that I fill in with my own dialogue and characters, trusting what I write enough to submit it all to black box venues downtown before I get overwhelmed by the whole application bureaucracy. Only after walking into National Black Theatre and talking to Nabii Faison able to locate a space to rehearse with the cast I had gathered by taping a call for audition to walls in the subway, and finally share the text I divided into two short plays titled "I Heard about Your Cat," and "A Table by the Window" with an audience. All I had to do was organize the mess that had collected in the men and women's dressing rooms over the years and the theater was mine to use, an informal agreement made with a local Harlem organization that will allow me to hear my writing spoken for the first time instead of sung.

As for smoke, pills, booze. I won't need those bells and whistles once I mature and calm down some. And once every damned inch of the street becomes prime real estate whose profitability is ensured by a police force with drone surveillance capability, New York will become a sorry extension of cyberspace in which every blink and sneeze is corporate sponsored, that I'll wholeheartedly reject.

Maybe the lack of foresight with which my parents dismantled our home when I was 18 predisposed me towards guitar smashing or I was destined to be the teen-

age squatter who boosted electricity off the sign of a Shell station. I'll be relieved to be evicted from my Harlem apartment. My move, a kneekerk effort to avoid an armed sheriff will be that of an avant-garde dancer rushing surreal props—and as for the window gate that was supposed to have divided order from chaos, I'll leave it, but it will already be unlocked and hanging from a loose hinge way before then of course.

jennifer jazz is a fledgling writer and musician who has performed mixed media shows at venues that include Dixon Place in New York and Bandini Espacio Cultural Gallery in Mexico City. jazz's notes have been published in *Moko, Sukoon, Booth, Warscapes, A Gathering of the Tribes, Afropunk, Black Silk: A Collection of African-American Erotica* and a couple of no-budget Xerox magazines. She appears in the 2018 film *Boom for Real: The Late Teenage Years of Jean-Michel Basquiat.*

CPSIA information can be obtained
at www.ICGtesting.com
Printed in the USA
LVHW021703170521
687659LV00006B/1503